Painting Acrylics

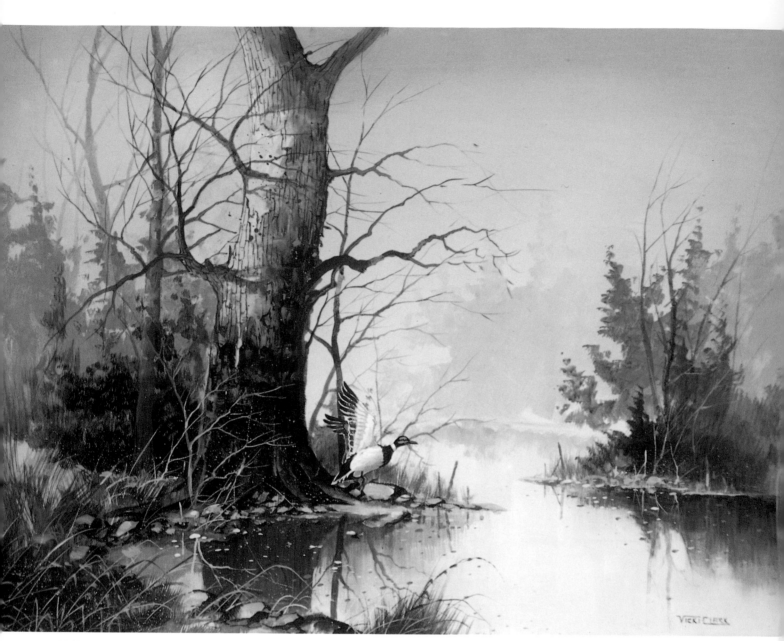

UNTITLED
18″×24″, acrylic
Vicki Lord

FIRST STEPS
SERIES

Painting Acrylics

VICKI LORD

NORTH LIGHT BOOKS
Cincinnati, Ohio
www.artistsnetwork.com

About the Author

Vicki Lord has studied at Purdue University, the Midwest Academy of Fine Art and with such artists as Robert Bateman, Zoltan Szabo, Irving Shapiro, Maxine Masterfield and Margaret Kessler. She is the author of two previous books: *Techniques in Acrylics, Alkyds, and Oils*; and *Fun With Alkyds & Oils: 12 New Paintings in Four Stages and in Full Color*. Lord has also hosted a PBS Instructional Painting Series broadcast in the United States, Canada, Mexico and Finland, which was later distributed on video.

Painting Acrylics. Copyright © 1996 by Vicki Lord. Manufactured in China. All rights reserved. No part of this book may be reproduced in any form or by any electronic or mechanical means including information storage and retrieval systems without permission in writing from the publisher, except by a reviewer, who may quote brief passages in a review. Published by North Light Books, an imprint of F+W Publications, Inc., 4700 East Galbraith Road, Cincinnati, Ohio 45236. (800) 289-0963. First edition.

Other fine North Light Books are available from your local bookstore, art supply store or direct from the publisher.

10 09 08 07 06 16 15 14 13 12

Library of Congress Cataloging-in-Publication Data

Lord, Vicki
 Painting acrylics / by Vicki Lord.
 p. cm.—(First step series)
 Includes index.
 ISBN-13: 978-0-89134-668-5
 ISBN-10: 0-89134-668-6
 1. Acrylic painting—Technique. I. Title. II. Series
ND1535.L67 1996
751.4'26—dc20 96-241
 CIP

Edited by Pamela Seyring
Designed by Brian Roeth
Cover photography by Pamela Monfort Braun/Bronze Photography

Thanks to each artist for permission to use their art. All works of art reproduced in this book have been previously copyrighted by the individual artists and cannot be copied or reproduced in any form without their permission.

fw
F+W PUBLICATIONS, INC.

METRIC CONVERSION CHART		
TO CONVERT	**TO**	**MULTIPLY BY**
Inches	Centimeters	2.54
Centimeters	Inches	0.4
Feet	Centimeters	30.5
Centimeters	Feet	0.03
Yards	Meters	0.9
Meters	Yards	1.1
Sq. Inches	Sq. Centimeters	6.45
Sq. Centimeters	Sq. Inches	0.16
Sq. Feet	Sq. Meters	0.09
Sq. Meters	Sq. Feet	10.8
Sq. Yards	Sq. Meters	0.8
Sq. Meters	Sq. Yards	1.2
Pounds	Kilograms	0.45
Kilograms	Pounds	2.2
Ounces	Grams	28.4
Grams	Ounces	0.04

Dedication

In Memory of Dad . . .
Because of him I have followed my dreams to reality

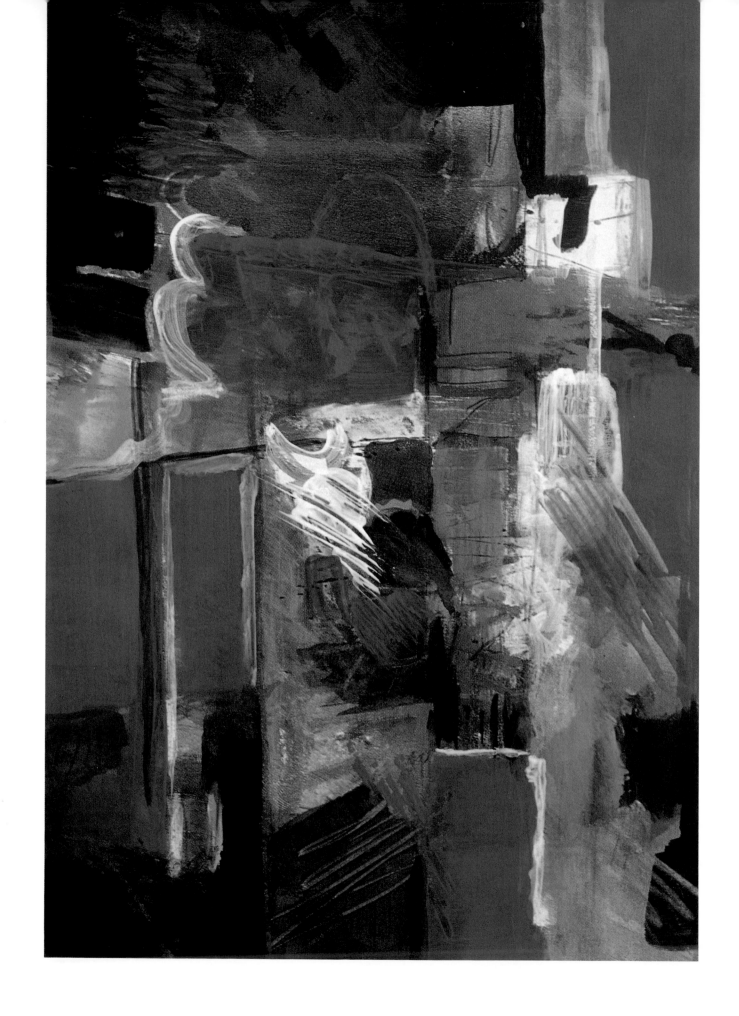

Acknowledgments

Because of some significant people, this book has become a reality. I want to thank my most wonderful editors: Greg Albert, for asking me to write this book and for his encouragement, suggestions and helpful criticism along the way; and Pamela Seyring. For hours of enthusiastic input, thank you to my husband, Maurice. With his knowledge of philosophy and English he transformed the pictures in my mind into colorful written statements. Thank you to my mother for the work she contributed to this project. I am also indebted to the contributing artists and educators who consented to have their work reproduced in this book; sharing their knowledge is a gift that will help all who aspire to become better artists. Most importantly, thank you to the thousands of students who make teaching an interesting and rewarding journey.

◄
FRAGMENTATION OF THE TOYS
16" × 20", acrylic on illustration board
Vicki Lord

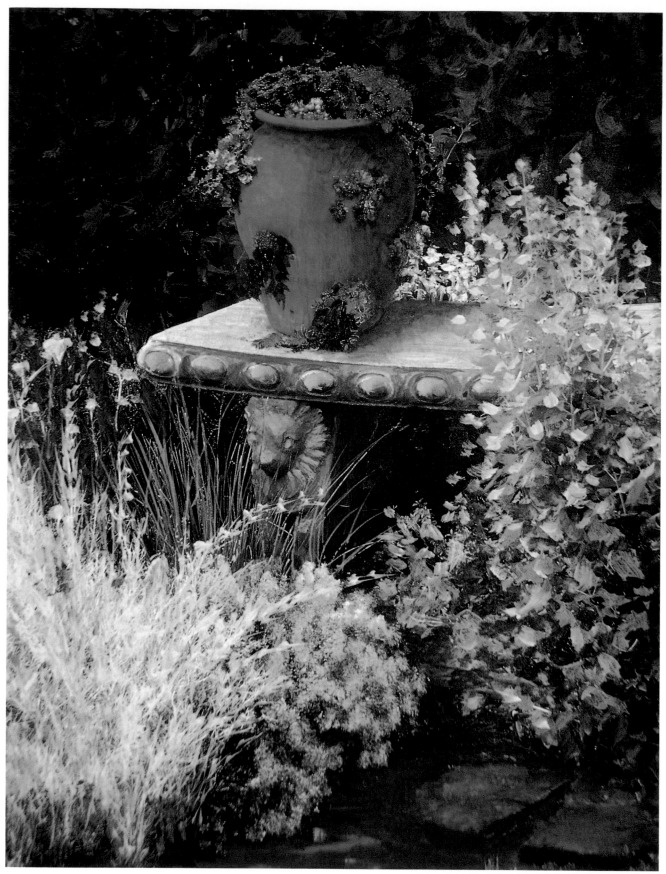

BEHIND THE GARDEN GATE
11″ × 14″, acrylic
Vicki Lord

Table of Contents

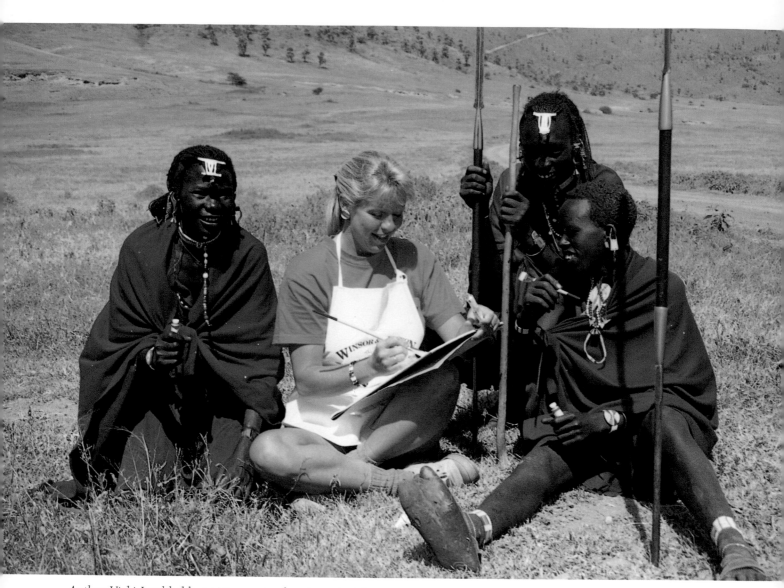

Author Vicki Lord holds an impromptu class in materials while painting on location in Tanzania.

Introduction

In the Swahili language, one word describes all of life's journeys . . . *safari*. Life's safaris provide us with unlimited sources of exploration evolving into a collection of experiences, images and visions which we, as artists, use to create small, unique worlds in which we make up all of the rules. In sharing these worlds, every painting becomes a journey for both artist and viewer.

This book starts a journey of discovery by revealing the many exciting ways acrylics can be used expressively; furnishing various approaches to technical information, helping you expand your skills, teaching about processes involved in constructing a painting, and inspiring you to experiment with alternative processes. But you must let the art be an *experience*, not an object. Give yourself permission to be a beginner. It is not always easy to paint beautiful pictures and expand your skills at the same time. Maintain a sense of adventure and be positive at all times.

Your painting journey will begin with facts from life, but should evolve and take many new paths along the way. Enjoy this journey through the artistic process. Come along. Share this painting safari.

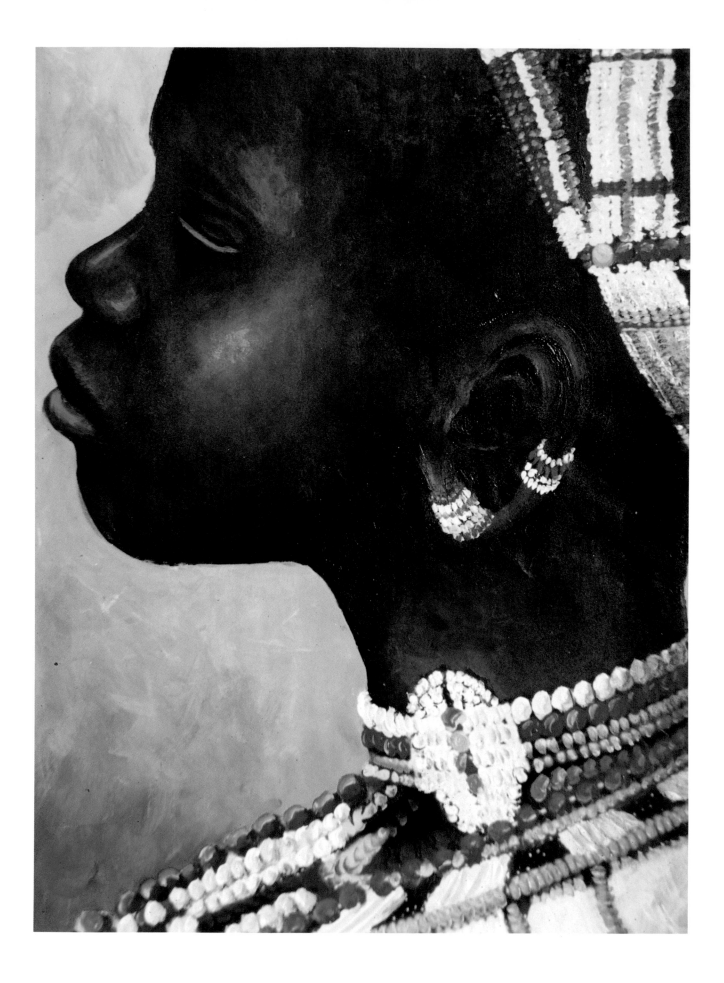

GETTING STARTED

The journey of learning to paint with a new medium can be exciting. Where do you start? What do you need? Brushes, paints, surfaces and palettes are the most important supplies. Various brush shapes and sizes can be used to create interesting effects; different brands and consistencies of acrylic paint are available; painting surfaces come in many types, such as paper, fabric, metal and wood; and palettes also have many styles, from disposable (my favorite) to those with hard, washable surfaces. Look around at your local art store. Try different things. Relax and experiment. Feel free to add other supplies to the following basics—you probably already have many of the things you need right in your own home. Materials and equipment should suit individual needs, because your choices depend on the final effects you want to achieve.

◄

MASAII GIRL
12″ × 16″, acrylic on canvas
Vicki Lord

Brushes

Fan

This brush, which can be soft hair or bristle, is used to create or blend texture.

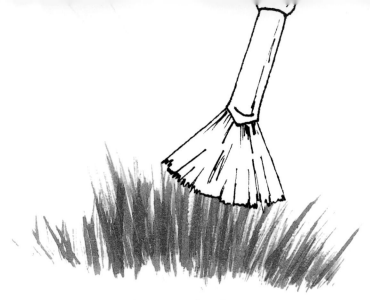

long upward strokes

short upward jabs

short jabs with tips of bristles

long strokes dragged
across the surface

light taps with corner and
tips of brush

Scruffy

This is an old, beat-up brush with bristles spread apart to make an irregular edge. It can be made by smashing tips on a hard surface or by trimming out some of the hairs at the tip of the brush.

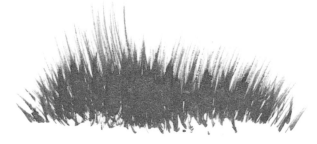

short upward pulls

Flat

Bright

Flats have elongated bristles, while brights are a shorter version of flats. Both can be used for painting many effects. The shorter hairs on the bright often show a more definite brush stroke. They are good for applying thick, creamy paint, and may be easier for the less experienced painter to handle. I use a bright when I want the brush to hold more paint, or when I want to achieve a softer look by using less pressure to eliminate brush strokes showing in the final piece. If possible, try testing the brushes before you buy them. This will give you an idea of the difference in how they feel. Remember, always work with the largest brush you can for the area you are working on.

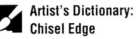 **Artist's Dictionary: Chisel Edge**

Drawing along the narrow, chisel-like edge of the tip of a flat brush to make a thin stroke, rather than making a wide stroke by drawing along its width.

chisel edge

flat edge

chisel and flat edges combined

Liner

A liner brush is used to create fine details such as tree branches, single blades of grass and individual hairs.

end of brush handle dipped in paint makes great dots

Hint

The paint should be of an ink-like consistency when using a liner or a rigger. This produces a flowing line.

Soft Hair or Stiff Bristle?

When should you use stiff bristle brushes, such as ox or hog? Or soft hair brushes, such as sable, squirrel, synthetic or camel? Thinner paint generally calls for a softer brush, while thicker paint calls for a stiffer brush. But rules were made to be broken, so experiment. Find what works best for you.

Brush Care

Acrylics dry very quickly unless an extender is added, so rinse brushes continually while you work. Wash with a good brush soap and water when you're finished painting. Rinse well and lay flat to dry. Standing a brush on its bristles to dry results in hairs bent at a strange angle, while standing a brush on its handle to dry causes water to leak down into the ferrule, loosening the glue that holds the bristles together.

Artist's Dictionary: Ferrule

The metal part of a brush that holds the bristles.

Round

This is a pointed brush used primarily for detail.

Hake

A hake (pronounced *ho-key*) is an oriental flat brush made of sheep or goat hair. It is used primarily for washes, but is also often used dry for softening.

ferrule

Filbert

This is a flat brush with an oval point, useful for strong, tapering strokes.

Acrylic Paints

Acrylics provide an exciting medium for experimentation. Here are some of their characteristics.

Durability

Composed of pigment bound in synthetic resin, dry acrylics are a permanent, flexible, nonwater-soluble plastic that resists moisture, cracking and discoloration with age.

Versatility

Acrylics are adaptable to a variety of techniques. Diluted with water, they handle much like watercolor. Less water produces a gouache-like consistency. The advantage is that, once dry, they are insoluble and can be overpainted without disturbing the paint underneath. Acrylics direct from the tube can be used like oils without the problems associated with toxic solvents such as turpentine. With a variety of additives available, texture can adapt to almost any technique. This allows the artist many approaches.

Drying Time

Acrylics dry rapidly, allowing the artist to quickly overpaint. This cuts waiting time. An extender prolongs drying.

Adhesive

Acrylic paints, used with acrylic gels and mediums, are excellent adhesives for making collages.

Color

A wide range of acrylics is available, and colors vary from brand to brand.

Hint
Most brands of acrylic dry darker than they appear when wet.

Winsor & Newton's Finity Artists' Acrylic Colors feature several benefits. The entire Finity line provides true hues that remain permanent, unlike many colors, such as Alizarin Crimson, which are traditionally associated with low permanence. Another beneficial feature is the minimal color shift from wet to dry. Color shift has long been a great frustration for acrylic artists, especially beginners.

Golden also produces high quality paints in various consistencies and many exciting colors, including Interference and Iridescent colors. One of my favorite products is their Fluid Acrylics, which are highly intense, with a thinner working viscosity for doing watercolor applications, staining and spraying, without the usual dilution of pigment strength when thinning down heavier-bodied paint with water.

Consistency

Acrylics can be purchased in a variety of consistencies which make them suitable for many types of applications. Tube acrylics are much like oils; jar acrylics have a more pourable consistency; and bottle or fluid acrylics are thin enough to squirt, or even spray with a little water added. Acrylics can be used for opaque coverage, or thinned with water or medium until transparent.

Painting Surfaces

Your painting surface has a significant impact on your finished piece. Effects

Artist's Dictionary: Extender

A medium added to the paint that retards drying, allowing more open working time.

obtained with paper will be different than on canvas, wood or metal. A knowledgeable salesperson in your local art supply store can answer many questions that arise concerning surfaces.

Canvas can be purchased in many ways. Prestretched and preprimed is the most convenient because it is ready to use. It comes in standard sizes, such as 9″ × 12″, 16″ × 20″ and 20″ × 24″. It is also available in rolls, to be cut, stretched on stretcher bars and traditionally prepared by applying two or three coats of gesso. Unprimed canvas, while less desirable for general use because of its high absorbency, can produce unusual results.

Watercolor paper comes in hot pressed (smooth), cold pressed (semi-rough—ideal for the less experienced painter) and rough. It ranges from 70-lb. (light weight) to 400-lb. (extra heavy weight). Heavier papers can be taped to a board with wide masking or drafting tape for painting. Lighter papers should be stretched. Here's how: (1) wet the paper well on both sides; (2) fasten all four edges to a board with wide gummed tape—the kind that must be moistened—making sure that at least half the width of the tape is on the paper; (3) let the paper air dry flat. Watercolor blocks are a good alternative to single sheets because they do not need to be stretched and secured to a painting surface.

Watercolor or illustration board is a high quality paper mounted to a stiff backing board. It is available in various weights and two textures—smooth (hot pressed) or slightly textured (cold pressed). No extra support or stretching is needed. Watercolor board makes a wonderful

painting surface for the less experienced painter.

Handmade paper can be used when a porous, more interesting surface is preferred.

Rice papers are handmade, oriental papers usually used for textural effects with collage.

Wood comes in many forms, including furniture and decorative pieces.

Masonite, which can be gessoed, is a pressed wood board with a smooth surface on one side. It is usually gessoed on one side before painting.

Experiment! Acrylics used on these various surfaces can provide many effects. They are well suited for almost any use because of their technical properties. I even use them for decorative finishes on walls as well as furniture.

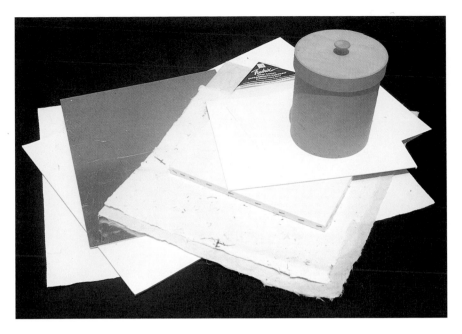

Palettes

Some of the most popular palettes are shown here.

Disposable palettes are wax-coated paper sheets.

Wooden palettes include the standby, oval-shaped palette with a thumbhole.

Molded plastic trays come in various designs, set up for holding paint and mixing.

Stay-Wet is a relatively new design. The plastic, molded tray has a sponge insert and special paper to keep acrylics moist.

My first instructor had me use a 24″ × 36″ piece of Formica or Plexiglas for a palette. It was great! Because of the palette's large size, I was able to put the entire color wheel, as well as tints and shades, on the palette each time I painted. This helped me learn about color relationships, color schemes and color mixing much more quickly.

Other Materials and Equipment

Acrylic varnish comes in gloss or matte. It is used as a final protective coating for paintings on canvas.

Acrylic medium, used to help make paint more transparent while not breaking it down too much, is also great for collage, as you will see in chapter three.

Friskets, masks and resists are all names for materials that keep paint from adhering to a particular area of the design. Frisket paper or film has adhesive backing. Liquid mask can be rubbed off when dry.

Gesso is a white primer used to base many surfaces. It can also be used in the painting process as a substitute for white paint.

Hair dryers can dry your painting more quickly, so that you can proceed to the next step. This is great when doing glazes on top of each other.

Large water containers, anything from buckets to coffee cans, come in handy for cleaning brushes, as well as for keeping clean water readily available.

Palette and painting knives are used for mixing paint.

Small airtight containers can be used to hold special mixtures of leftover paint.

Sponges can be used for interesting painting techniques, as well as for wiping up messes.

Squirt bottles loaded with water can be used on both the palette and painting surfaces to keep them moist for fun techniques.

THE CHORUS LINE TAKES A BOW
12" × 16", acrylic on canvas
Vicki Lord

DEVELOPING A PAINTING

The journey of painting does not start with brush and paint, but with time spent mapping out your route. Although there are no rigid rules in building a design, there are some guidelines that can help organize the spaces. Apply these guidelines when intuition tells you they are needed. Don't become a slave to rules, but you should be able to handle technical problems before you can become expressive.

Reference Material

Painting from actual subject matter is an ideal situation, but it is not always possible. Photos or slides are the next best thing. Take several of each subject, from different viewpoints. This will allow you more reference material from which to study and choose. Then you can pull from your files as many photos as you need, and play with the puzzle pieces until you've decided on a composition. Use your artistic license to change subject matter, color, shapes, etc., as long as the final painting remains believable.

A photo of zebras in various positions, used for reference

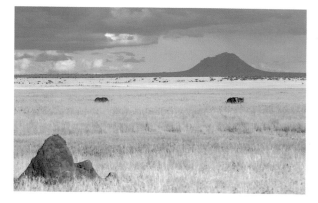

Reference slide of cumulus clouds

Tree and background hill used as subject matter for the final painting

A termite hill used for color reference

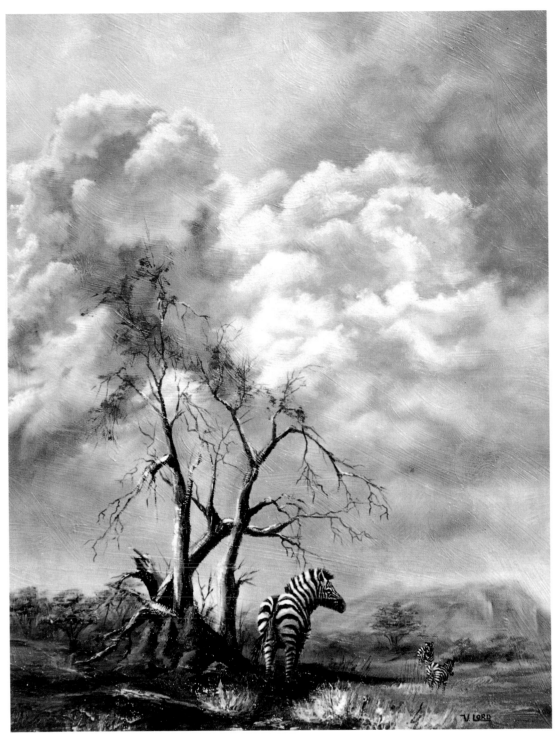

SERENGETI STORM
14″ × 18″, mixed media on canvas
Vicki Lord

Putting the Pieces Together

Try experimenting with the following method for deciding placement of subject matter in a composition:

1. On tracing paper, draw any objects whose place in the composition you are not sure of.

2. Cut them out.

3. On a separate sheet, draw basic elements of a composition that work well in your thumbnail sketches. These elements might include a horizon line, background trees, or, if you have decided on the placement of your center of interest, you may want to work other objects around it.

4. You can then move the cut-outs, or "puzzle pieces," around the drawing quickly and easily instead of doing lots of erasing.

Thumbnail Sketches

Small, quick, easy and without much detail, thumbnail sketches are notes for ideas to be developed later. Make several for each painting. For example, try your center of interest in various positions. In "Serengeti Storm," on page 23, I wanted the painting to be as much about the sky as about the zebra, although the animal is the focal point. A vertical format helped achieve this, and I was able to make that decision quickly using thumbnails. Explore the principles and elements of design with thumbnail sketches. These sketches are a great way to explore shapes, patterns and spatial relationships for compositions.

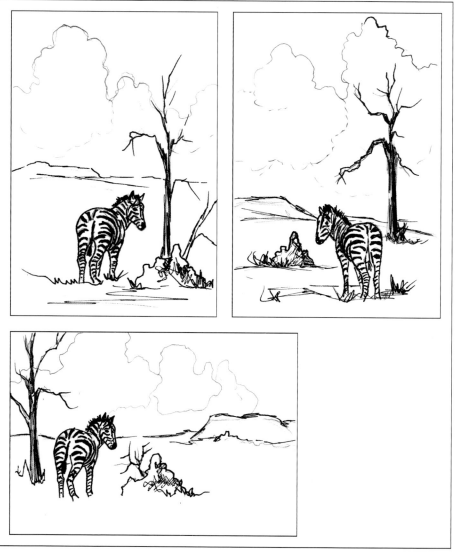

Visualizing the Painting

Subject Matter

What do you want to paint? A landscape with water, trees or buildings? A still life with flowers and fruit? Wildlife or domestic animals? A portrait? A combination of subjects?

Center of Interest

Center of interest, or emphasis, is the subject, object or area of a painting that is to be given special importance through placement and treatment. It is the focal point, or main attraction. What do you want to be the most important area or object in the painting? Although it is important to have one center of interest, it is a good idea to entertain the viewer in the foreground, middle and background to some extent.

Format

Format refers to the overall dimensions and shape of a piece. Will it be large or small? Vertical, horizontal or square?

Composition

Composition is the manner in which everything is arranged in a painting. It consists of understanding and effectively using the elements and principles of design. Composition has no rigid rules, but there are some guidelines, principles and simple dos and don'ts that help you organize spaces and objects in your paintings. They apply equally to all types of painting whether it is a landscape or floral, abstract or realistic. But remember, they are only guidelines, and many successful paintings have been made ignoring all rules and guidelines. No matter how you arrive at the end result, the ultimate goal of a good composition is unity—that point when everything in a painting works together.

How do you want to arrange the objects in your painting? Consider the composition dos and don'ts on pages 32–35.

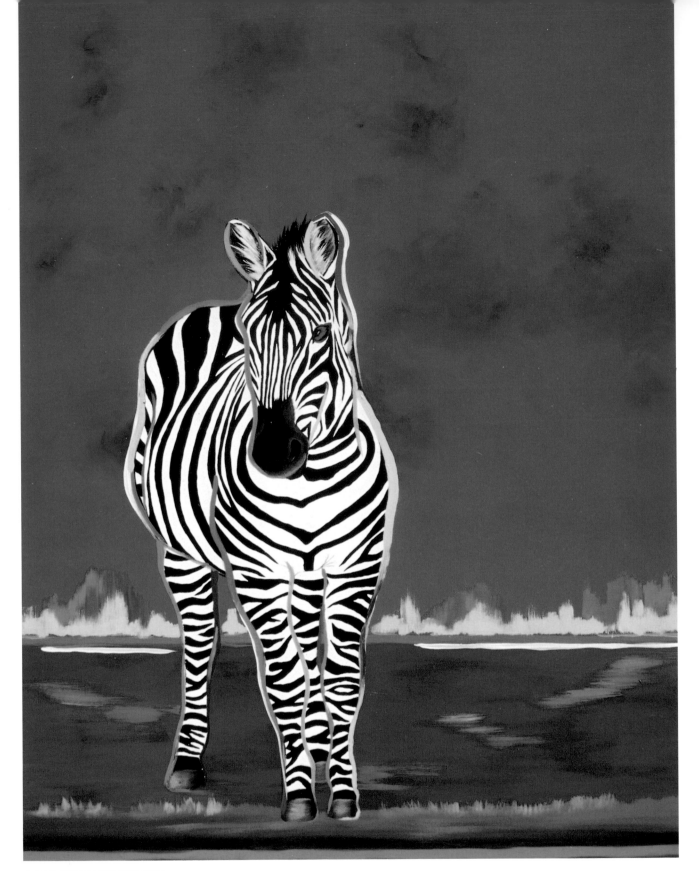

COAT OF MANY COLORS
30″ × 40″, acrylic
Vicki Lord

Color

What colors will you use? When mixing or painting, color becomes much easier to understand when broken down into its various properties.

Cadmium Yellow Light or Lemon Yellow

Cadmium Yellow Medium

Cadmium Orange

Olive Green

Cadmium Red Light

Warm Colors

Cool Colors

Viridian

Complementary Colors

Phthalo Blue

Cadmium Red Medium

Ultramarine Blue

Alizarin Crimson

Dioxazine Purple

 Artist's Dictionary: Hue

Name of a color as we categorize it, such as red, green, blue, etc.

Intensity

The brightness or dullness of a color.

Color Temperature

Warm colors are those in which red, orange and yellow predominate. Cool colors are those in which blue, green or violet predominate.

Primary Colors

Red, yellow and blue. Two primaries can be mixed to make a secondary color, but primary colors cannot be mixed from any of the other colors combined.

Secondary Colors

Orange, green and violet, made from mixing the primaries: red and yellow make orange; blue and yellow make green; red and blue make violet.

Complementary Colors

Directly opposite on the color wheel. When mixed together they form a shade; the intensity of the color is muted or neutralized. When placed side by side, they make each other appear more intense, or "pop out" at the viewer. This can be helpful in using complementary color schemes, emphasizing a center of interest or shading objects.

Analogous Colors

Closely related and adjacent on the color wheel. Blue, blue-green and green are analogous to each other.

Shade

The degree of color obtained by adding black or a complement to a hue.

Tint

White with a small amount of color added. The more color added, the stronger the tint.

Elements of Design

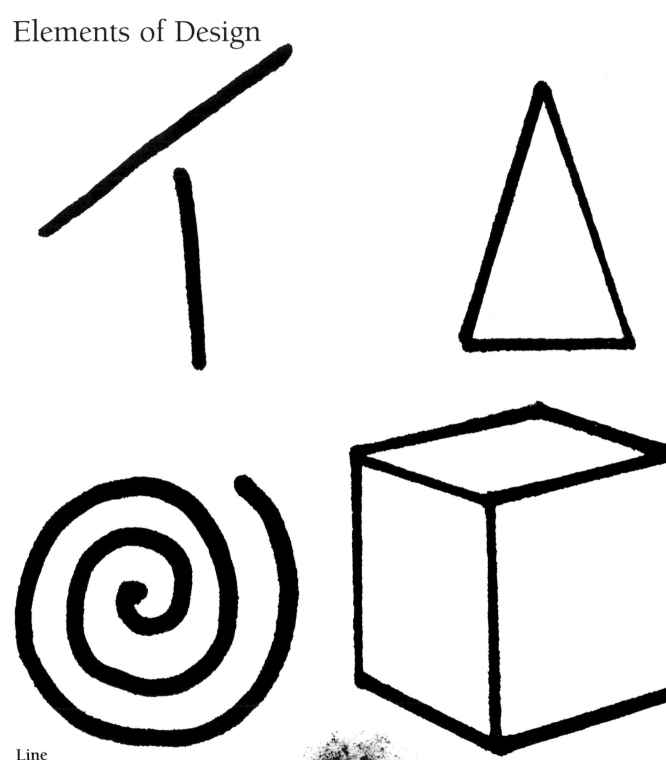

Line

Lines create a sense of movement or direction and define the boundaries of shapes. The term line may also refer to a set of elements that leads the eye through a work of art.

Texture

Texture can be either actual or suggested surface differences.

Shape and Form

Basic and irregular shapes, or forms, construct visible characteristics of objects and spaces.

Size

The relative size and proportions of design elements can create spatial relationships, such as depth, as well as contrast.

Space

Positive space is the area containing the subject matter in a composition. Intervals between objects are called negative space. Negative and positive spaces can determine rhythms, patterns, the representation of depth, and other relationships between elements in a painting.

Movement

Movement is the quality of representing or suggesting motion. Movement directs the viewer's eye through a painting and can create a mood, such as calmness or agitation.

Value

Value, contrast and key refer to the lights and darks in a picture. High-key values are light; low-key values are dark. Dark and light values can create depth and visual strength, as well as moods. More about value is discussed later in this chapter.

Principles of Design

Balance
In composition, balance is a state of harmonious proportions or symmetry according to visual weight.

Dominance
Dominance is used to resolve conflict by creating an appropriate center of interest that's more prominent due to size, value, intensity, placement, etc.

Alternation
A rhythm that is created by interchanging or taking turns with objects, color, sizes, etc.

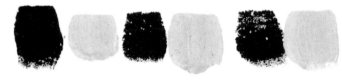

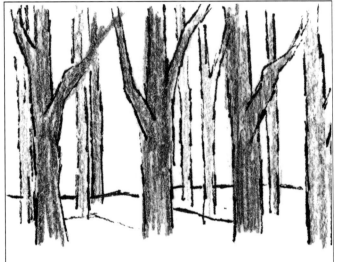

Rhythm
A cadence or tempo created by the regular or irregular spacing of lines, colors, shapes, etc.

Repetition With Variety
Repetition refers to the same elements occurring several times in a design. Variety is the use of different patterns, values, lines and shapes in a painting. Repetition creates harmony and movement, but needs variety to avoid being tedious or boring.

Gradation
In composition, gradation refers to an arrangement of design elements forming a gradual, progressive change by regular degrees, such as out of focus to in focus, large to small, or dark to light.

Contrast
Contrast refers to the degree of difference or similarity between design elements, such as short or long, dark or light, energetic or placid.

Building a Composition Around One Element or Principle of Design

Kathie George explains, "I began this painting with two goals in mind. First, to use one of the principles of design, *alternation*, throughout the painting. Second, I was hoping to break free of my usual soft, uncomplicated painting style.

"Because I rarely paint people, I chose an African head from my sketchbook and drew it first one way, then flipped it over to face the opposite, or *alternating* direction, changing it slightly. The design in the background, behind the heads, is an African motif. I used two small sections of the motif and *alternated* them to form the border. Next, I applied the design to the 140-lb. watercolor paper with latex paint in a squeeze bottle.

"The colors used in the painting were chosen when I found several tubes of never-before-used fluorescent gouache (an opaque watercolor) in my paintbox. I decided to experiment. Mixing them with water to a liquid consistency, I painted some soft strips of color onto the wet paper, allowing some of it to float onto the subject. When dry, I wet the border area, placing Fluorescent Blue along the center, fading outward. Next, Fluorescent Orange was floated onto the faces, with bits of Magenta, Burnt Sienna, and Phthalo Green to shade. Using a small brush I filled in all of the tiny areas of the motif design keeping the color washy, but gradually switching from one color to the next. Some of the color mixes within the detailed motif are: Alizarin Crimson and Winsor Violet; Phthalo Blue and Phthalo Green; and Fluorescent Blue, Mauve, Orange and Red.

"In contrast, the subject, leaves and faces, are left simple, almost unpainted, so that they come forward and separate themselves from the busy background."

Experiment

One way to become more familiar with elements of design, and have fun at the same time, is to choose one principle or element and develop an entire painting or quick mini-composition (approximately 8″ × 10″) around it.

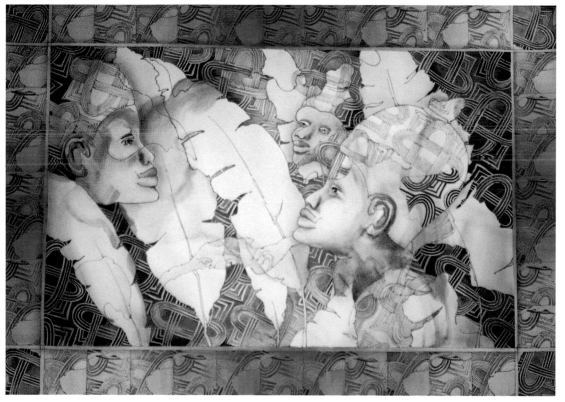

CRIES OUT MY HEART
30″ × 42″, mixed media on watercolor paper
Kathie George

Composition Dos and Don'ts

Do try different spacing.

Don't cut objects in half. Why would an elephant have a tree growing out of its back?

Do place objects either totally inside or partially outside of the frame.

Don't tickle the edges of the painting.

Do overlap objects to create depth.

Don't place objects barely touching or tickling the edges of each other.

Do group objects creatively.

Don't balance elements too formally, so that they cut the painting in half.

Do try to suggest distance and depth accurately. This includes making objects appear smaller and parallel lines appear closer together as they recede into space.

Don't do it like the example below.

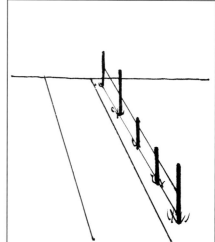

Do make dominant lines lead the eye into the frame.

Don't direct them out of the painting.

Do try to group objects in odd numbers, not even.

Do try to lead the viewer's eye into the picture frame.

Don't place heavy, center-of-interest objects in a corner, or leading out of the picture.

Value

UNTITLED
32″ × 44″, acrylic
Jan Miller

Value, the lights and darks in a picture, is one of the most important elements of a good painting. Color and line alone cannot paint a picture; they must have the support of value contrasts. Therefore, establishing a good value pattern is essential. Small black-and-white thumbnail sketches should be made, breaking the painting down into values. This lets you see several things clearly. You can tell at a glance whether the painting has a good balance. Too many darks in the distance? Too heavy with dark values on one side? Does your value gradation establish depth and create realistic forms? Two overlapping shapes should not be the same value. One must be darker or lighter than the other, to separate them. Trees in a forest are a good example. Without value changes, all of the greens begin to run together, and it is hard to tell where anything begins or ends. Once value patterns are established, it is much easier to insert the correct value of any color into the painting.

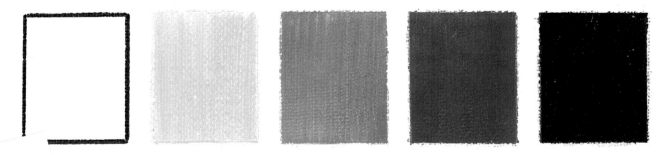

Value Scale

Value Recession

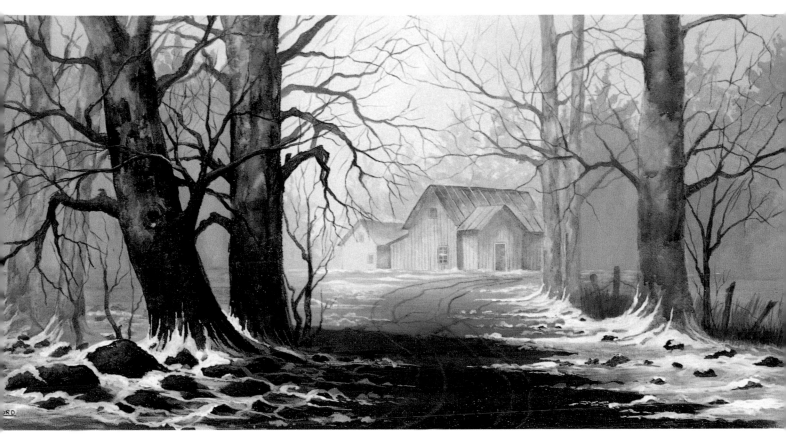

WHAT THE MIST LEAVES BEHIND
15″ × 30″, acrylic on canvas
Vicki Lord
Private collection

**Artist's Dictionary:
Value Recession or
Atmospheric Perspective**

A method of conveying space and
expressing distance in a painting by
gradually changing the values from
foreground to background. When
you look into the distance, general
atmospheric conditions such as dust
and smoke can diminish the degree
of light-dark contrast. If you place
very dark values in the distance, they
will advance and compete with the
foreground. Very light, bright values,
such as sand, snow, and reflected
lights on water, become more dull in
the distance. This makes them appear
slightly darker.

Rendering Form With Value

Form is rendered not only through shape, but also by the way light falls on that shape, giving it definition and creating value changes on the object.

**Artist's Dictionary:
Bridge Color**

A medium-value color applied to ease the transition between two other colors.

Sphere

Light Source

Highlight

Light

Medium
(local color)

Bridge

Dark

Reflected Light

Finished painted form

Hint

If you're having trouble getting values blended before drying starts, mix extender into your paint to lengthen the available working time. Also try applying one value, then applying the value next to it, and quickly blending these before applying the next value.

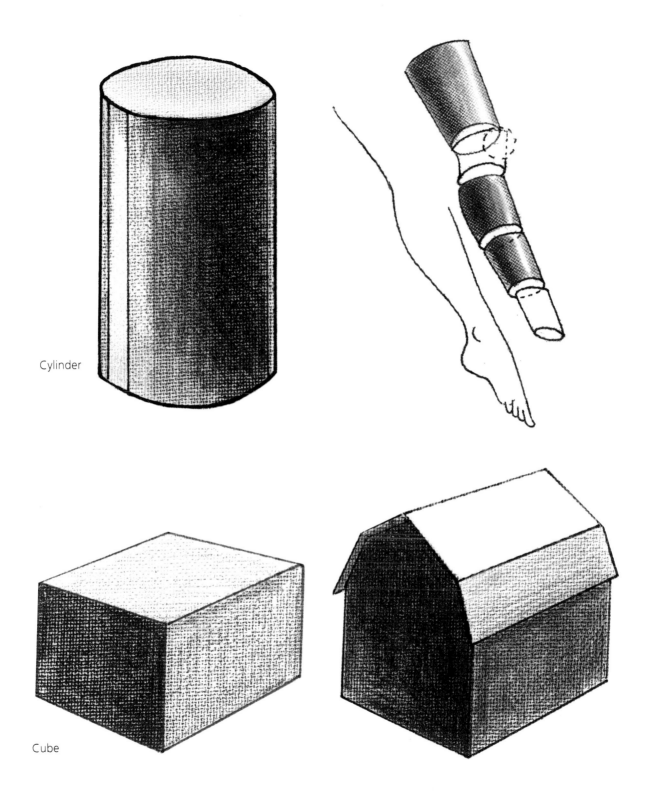

Cylinder

Cube

There is no need for a bridge color when you have a corner.

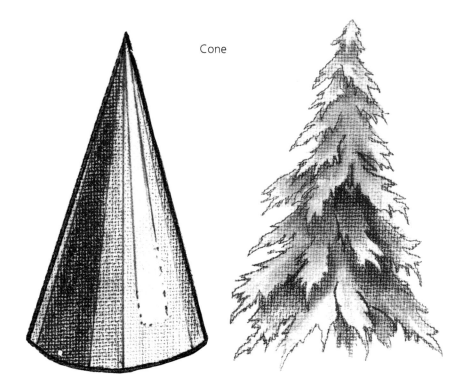

Cone

Hint
When shading objects which are not solid, such as the tree at left, you must think of shading the separate parts (in this case the branches) as well as the whole. There will be light and shadow in places where you would not find them on a smooth, solid surface because of the various depths of the forms.

Hint
If you're having trouble establishing values with color, a value underpainting helps to map out value changes before adding color. Try the method described in the "Teddy and Quilt" demonstration on pages 96-99.

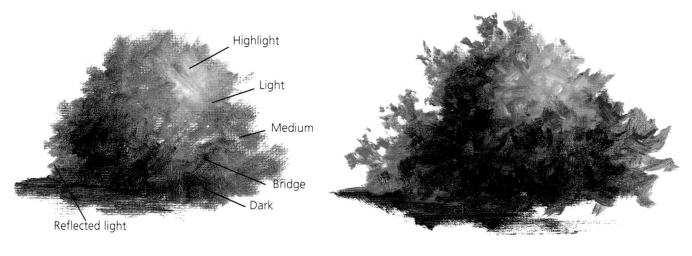

Highlight

Light

Medium

Bridge

Dark

Reflected light

Base in values.

Add leaves with corresponding values.

OLD LACE
24″ × 36″, mixed media on canvas
Vicki Lord
Collection of the artist

Chapter Three

PAINTING TECHNIQUES

Sometimes it is hard to explain the "how" of brushwork. It is a composite of technique, experiment and expression.

This chapter will show you various techniques for painting objects. Learn from them, experiment with them and build on them.

It is much easier to be expressive when you understand a few basics. Experimenting with ideas from many different artists will give you information that will allow you to explore. Use those techniques that are most comfortable for you; discard others. Experiment, build and grow as the painting journey evolves.

◄
SPRING IN SEARCH OF ITSELF
11″×14″, acrylic
Vicki Lord

Flowers

Flowers are simply shapes and forms with color added, but the separation of the petals is very important in understanding their structure. In this painting, I concentrated on making the elements realistic, but softened the overall effect with painterly brushstrokes.

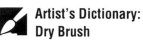

Artist's Dictionary: Dry Brush

A method of painting with very little moisture on the brush. Drybrushing creates an uneven effect.

Painterly

Appearing loose in style; having the effect of spontaneous paint application.

NATURE ERUPTS FROM GEOMETRIC STRUCTURE
12″ × 16″, acrylic on handmade paper
Vicki Lord
Private collection

1. Block in Values

Start by making a drawing identifying various parts of the flower. Record values in an underpainting, without too many details, simply blocking in color to set up a general description of petals. Establish the beginnnings of a background by choosing a color scheme and using a basic structure of loose brushwork.

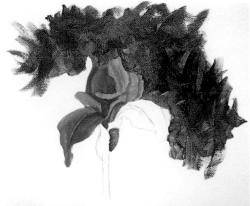

2. Add Opaque Color

In this step, strengthen shapes by adding more opaque colors to the petals using drybrushing and blending. Pay close attention to the basic values set up in step 1.

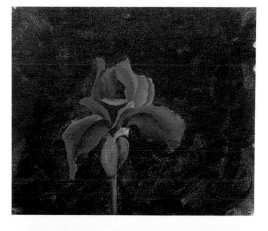

3. Contrast, Balance, Depth

Complementary colors of turquoise and lighter green were added to the background, shoving against the positive area of the flowers to develop a secondary contrast to the design. Touches of the flower colors were also added to the lower right background for balance. Dark values in the flowers were strengthened, adding more depth to the shapes.

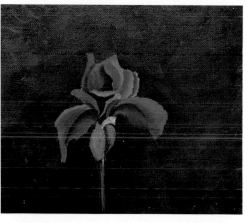

4. Finishing Touches

Clean up edges of petals and add highlights. I decided to add a geometric form against the organic subject matter. A bright, bold line was added with a pastel pencil to break up the dull black geometric area.

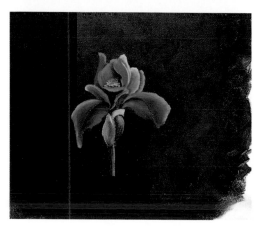

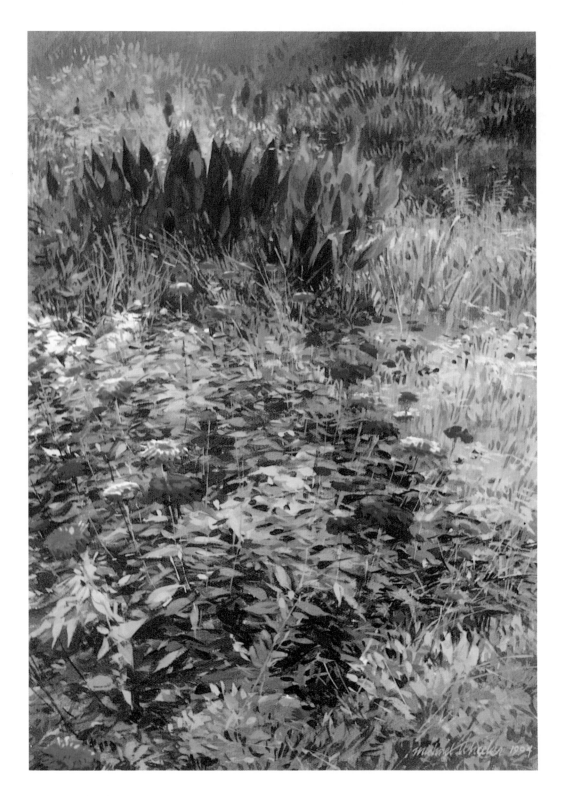

"In establishing the composition, I try to lead the viewer back into the painting," says Michael Wheeler. "This is done here with the placement of the flowers and also the converging lines of shadow. I wanted to create the mood of a hazy, quiet August morning, and tried to accomplish this through the limited use of white or light transparent washes in the background. I paint the flowers as I do anything else: a rough shape of local color, then higher and lower values to define shape, and finally a refinement of form, color and value as details are added.

ZINNIAS AND CANNAS—
LATE SUMMER
14″ × 18″, acrylic; Michael Wheeler.
Collection of Mr. Robert Mason, NC.

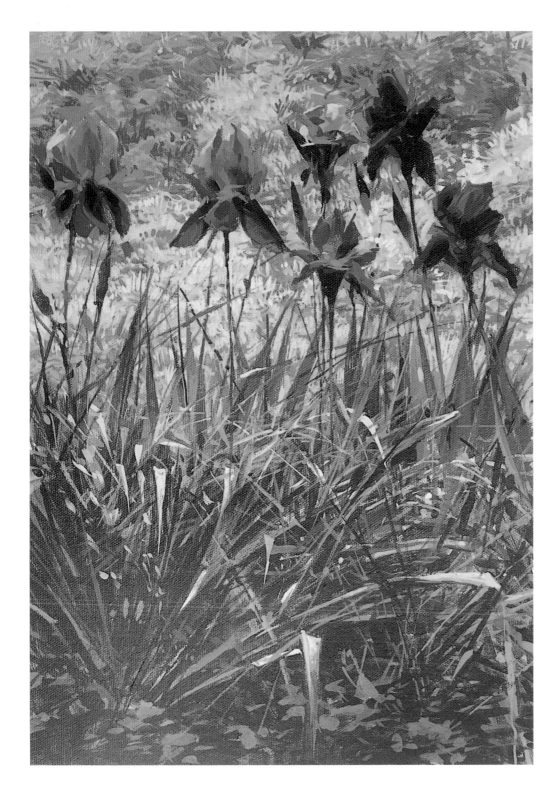

"I used a mixture of Alizarin Crimson and Cobalt Blue to paint the purples in this iris painting," Michael Wheeler says. "Lighter values are achieved with white and crimson, and darks with more Cobalt Blue, and maybe a touch of Ivory Black. The yellow in the background adds to the intensity of the purple, its complement. The dark foliage provides a massive foreground base to give a foundation for the more delicate stems and flowers to sit on. The slashes of highlight provide a transition from dark foreground to light background."

PURPLE IRIS
12″ × 16″, acrylic, Michael Wheeler. Collection of Mr. Dick Johns, Orlando, FL

Grass

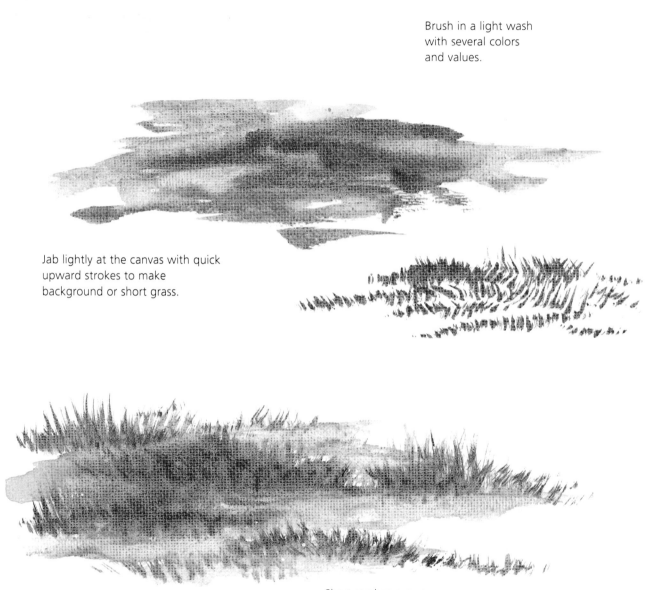

Brush in a light wash with several colors and values.

Jab lightly at the canvas with quick upward strokes to make background or short grass.

Short strokes over a wash of several colors

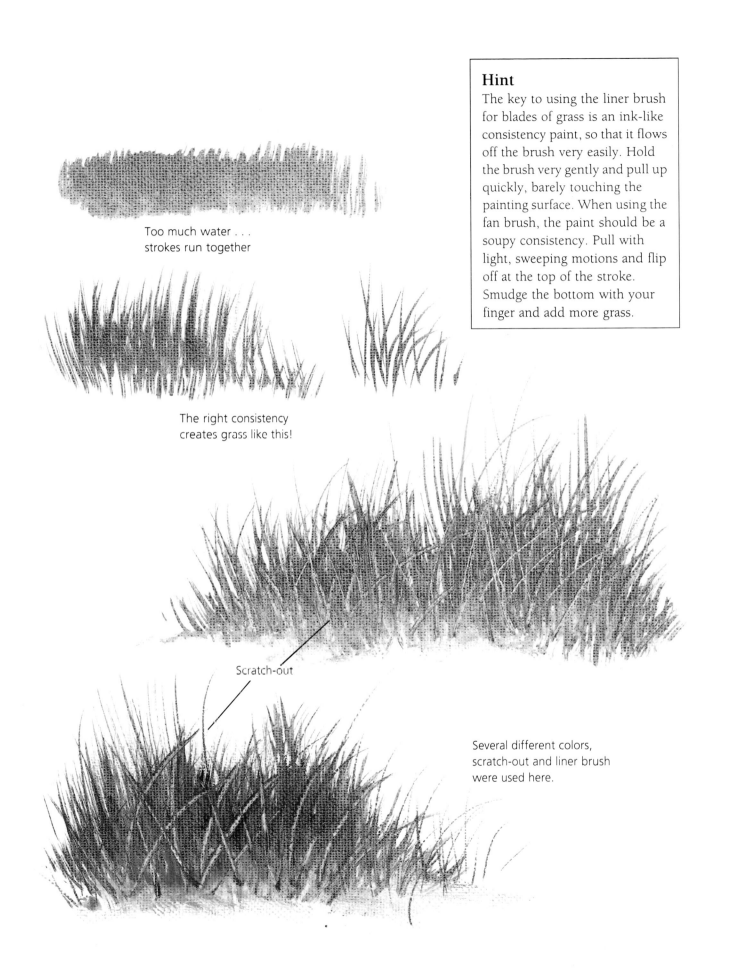

Too much water . . .
strokes run together

The right consistency
creates grass like this!

Hint

The key to using the liner brush for blades of grass is an ink-like consistency paint, so that it flows off the brush very easily. Hold the brush very gently and pull up quickly, barely touching the painting surface. When using the fan brush, the paint should be a soupy consistency. Pull with light, sweeping motions and flip off at the top of the stroke. Smudge the bottom with your finger and add more grass.

Scratch-out

Several different colors,
scratch-out and liner brush
were used here.

Weeds and Grass

For laying in weeds and grasses that are near you, start by pulling up some basic grass with a fan brush. Scratch out and/or pull up more grass with the liner brush. Then if you want some variations, fill in with some weeds. Combining some or all of the grass techniques and using different colors will let you create many different scenes and seasons.

Michael Wheeler says, "The colors I use for painting foliage, dry grasses and weeds are somewhat more intense than what is actually there, because pigment tends to look dull even if the color match is precise. I lay in general areas of local color and value with bristle brushes, then slash in lines and marks with a no. 4 sabeline brush. I work quite rapidly, trying to establish lines of movement around the painting which lead to the focal point; the red flowers in this case. My normal palette for foliage is Ivory Black, Burnt Umber, Napthol Red, Cadmium Orange, Cadmium Yellow Medium, Yellow Ochre, Hooker's Green, Cobalt Blue, Permanent Green Light and Titanium White."

Artist's Dictionary: Sabeline Brush

A dyed ox-hair brush designed to serve as a substitute for sable; useful, relatively inexpensive, used mainly with water-based paints.

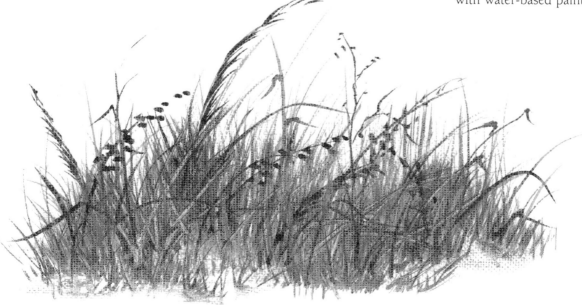

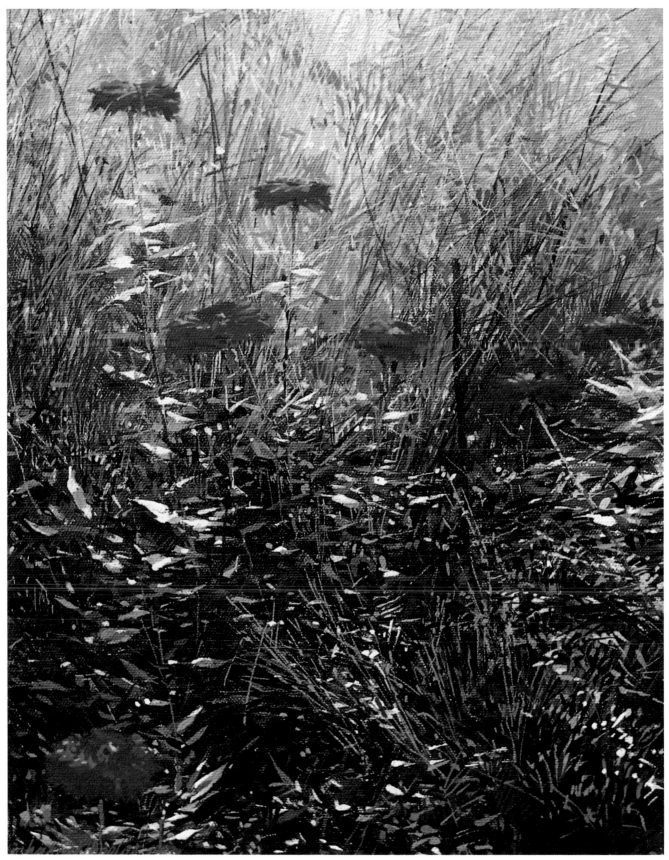

SPARKLING ZINNIAS
11″×14″, acrylic, Michael Wheeler.
Collection of William Wood, Carefree, AZ

Trees

Bark or Weathered Wood

1. Apply soupy paint.
2. Wrinkle plastic wrap and lay on top of paint.

Reference photo

3. Press down on plastic wrap then lift.
4. Add dark shadows for depth.
5. Add line work with the liner brush for detail.
6. Add extra washes of color and texture for interest.

There are many ways of creating textured effects on tree trunks. As you have seen, plastic wrap works well. Here are examples of some other types of tree techniques. You can also experiment with ideas of your own. Try wax paper, blotting with tissue, alcohol drops, or even gel or tissue applied before painting.

Mark Polomchak used Cerulean Blue and Alizarin Crimson as a base wash for this tree, but only in spots. Bluish Gray, Alizarin Crimson and Van Dyke Brown were added in the dark areas. Water spots were dropped on, then lifted off to create lighter areas for texture. A palm print was added to the lower section for texture. Lighter-value limbs were pulled out behind the trunk for depth, while white paint was added to the highlighted edges of those crossing in front, popping them out and away from the trunk. Finally, cast shadows were washed across the tree.

BIRD IN HAND
14″ × 18″, mixed media on watercolor board
Mark Polomchak

Various combinations of Burnt Umber, black, white, Cadmium Orange, Ultramarine Blue, and Cadmium Red Deep were used for this tree. Mixtures of these colors were first applied in a very wash-like consistency by dabbing the brush in different directions for a patchwork effect. Water was then tapped onto the surface in some areas and allowed to run down the tree. After this was dry, the technique was repeated several times, adding a fingerprint here and there for more texture, all the time paying close attention to value placement. Alcohol was added in a few places to repel paint. All of these small techniques add interest. Limbs were added in back of the tree to create depth, and a very pale tint of white and Cadmium Orange mixture was added to the limbs for highlights, especially where they crossed in front of the tree. Flyspecking was added last.

Tree Limbs

Notice how the limbs attach to the trees in this close-up. Size is proportionate and color is consistent.

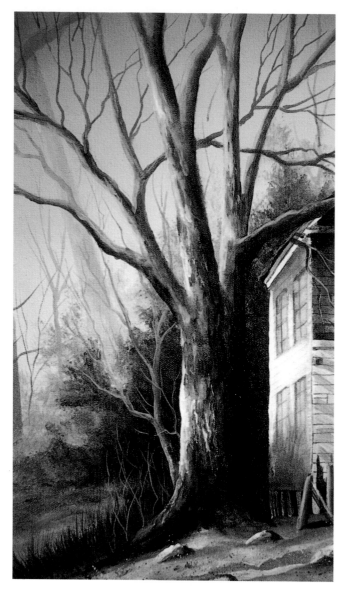

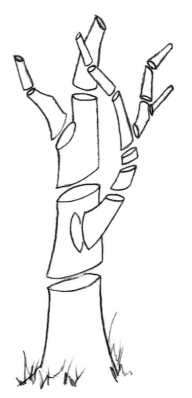

Different size cylinders fit together to form a tree.

Hint

When painting tree limbs, make sure that they do not look like they have been nailed to the tree, as opposed to growing from it. Most limbs are larger at the point where they attach to the tree, and gradually get smaller. Also, make sure that the color of the limb is consistent with the area of the tree from which it is growing.

Correct

Incorrect

1. Wide to Thin

Choose a brush that is the width you want your tree limb to be at the point it attaches to the trunk. Lay the brush flat on the surface and pull out, turning the brush slowly until it ends up on the chisel edge. This is an easy way to go gradually from large to small and wide to thin. When the chisel edge becomes too wide for the smallest parts of the branches, it is time to pick up the liner brush.

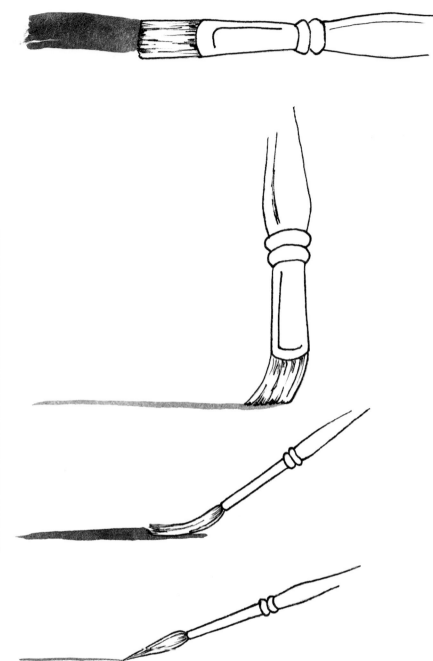

Hint

For natural-looking small branches, pull the brush slowly, keeping the movement nervous and jerky. Limbs are crooked and rugged, with lots of character.

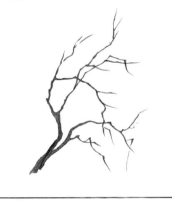

2. Liner Brush

Thin paint to the consistency of ink. Place the liner brush on the part of the tree limb that is already painted, instead of at the edge of the painted area. This will help to make a smoother transition. As you move towards the tip of the limb, gradually lift the brush, applying less and less pressure, until it is on the very tip of the hairs.

Evergreens

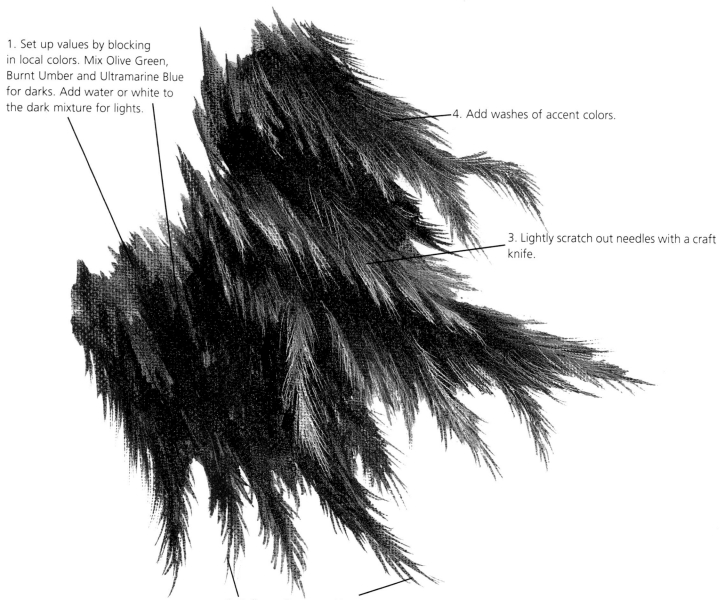

1. Set up values by blocking in local colors. Mix Olive Green, Burnt Umber and Ultramarine Blue for darks. Add water or white to the dark mixture for lights.

4. Add washes of accent colors.

3. Lightly scratch out needles with a craft knife.

2. Pull needles out with a liner brush.

Limbs With Foliage

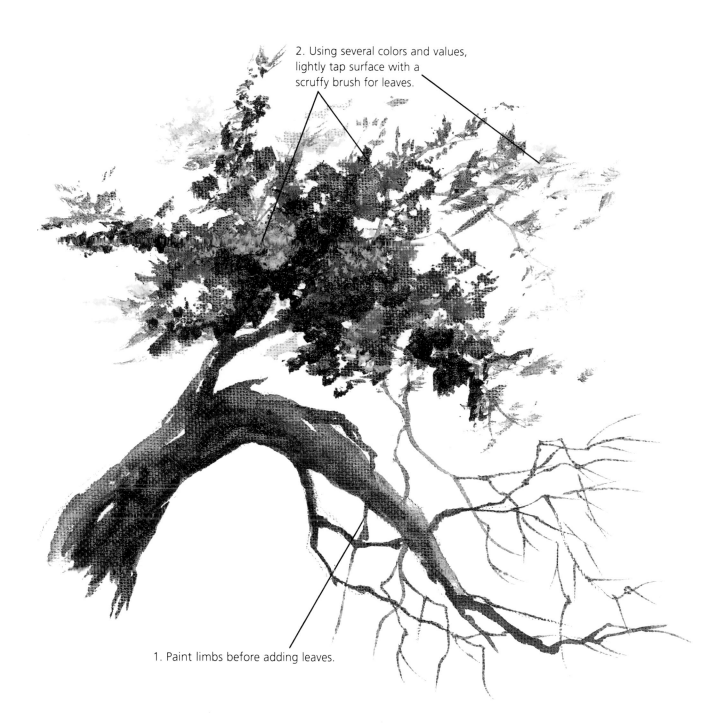

2. Using several colors and values, lightly tap surface with a scruffy brush for leaves.

1. Paint limbs before adding leaves.

Flowering Trees

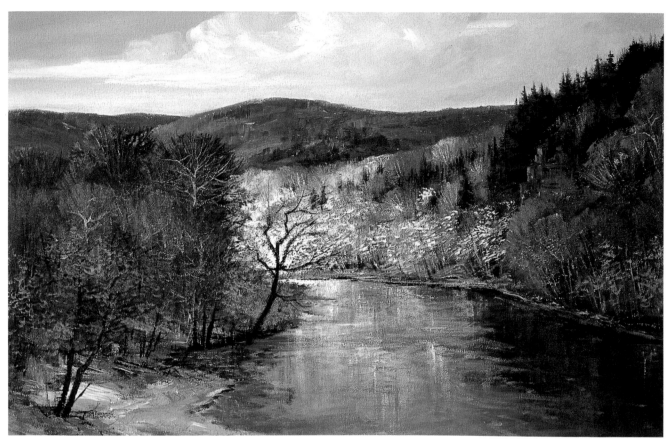

CURRENT-LY SPRING
22" × 28", acrylic
Joseph Orr

"I did this painting from photos and sketches of National Riverways Park," says Joseph Orr. "Dark colors, such as Raw Umber, were applied first, using a 1-inch flat brush to set up a background. I then added various base colors to indicate foliage areas. Thicker paint was applied with a fan brush, stroking either down or left to right, to create ravines. I added the colors for the flowering trees when this was dry. When I saw this scene, the colors looked like confetti spread over the landscape. I turned them into color sequences, using a small, triangular palette knife to tap paint lightly, with a motion much like that of playing the piano, for sparkling effects. When using a brush the wrist is tighter, therefore, a palette knife was used here for a looser effect. Cleanup was done using no. 0 and no. 1 pointed, round brushes."

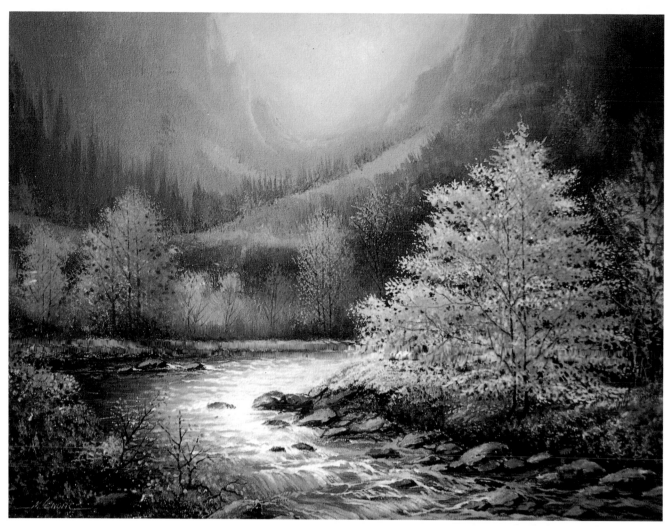

Milton Lenoir says, "Most of my paintings are constructed from nature and from my life experiences. I usually try to create a mood with color, subject matter, technique and center of interest. I use acrylics on white canvas, working with many transparent layers. That way, I am able to keep the color clean, avoiding muddiness. I used a 1-inch brush, painting suggestive strokes, to place background washes. I tried to leave open areas while blocking in colors. I then went back over the top of this several times with darker values, establishing various elements. I used the corner of a sable fan brush for much of the foliage, tapping the paint on the surface with paint of a creamy consistency, keeping in mind my center of interest, the dogwood. I kept my most intense colors in the foreground, graying them in the distance to create depth. Finishing details included placing see-through holes in the foliage, breaking up the color. I also used a liner brush for details and doodles."

DOGWOOD VALLEY
22″ × 28″, acrylic on canvas
Milton Lenoir
Private collection

Rocks Using Rice Paper

Rocks can become as textural as you wish, depending on the type of rice paper chosen: thick, thin, transparent, fibrous or smooth.

1. Medium and Paper

Apply the rice paper by brushing diluted acrylic matte medium onto the painting surface, laying down the paper, then brushing over the top with more medium to saturate all of the rice paper and assure good adhesion. Leave this to dry before adding paint.

2. Color and Shape

Apply washes of various colors to the collage, paying attention to the development of shapes. Develop the crevices between the rocks. Some light colors can be added to the tops of the rocks. Several layers of paper can be built up, with washes in between, to add even more texture.

3. Finishing Touches

Continue to define the crevices and rocks with more dark color washes. Pull up some grass or weeds in these areas perhaps. Finally, add highlights to the tops of the rocks by dry brushing with lightest values.

A good example of rice paper being used for textural effects in a painting is seen in chapter four in the collaged landscape by Kathie George. A light sketch or wash of color to establish a design may be applied before the rice paper, or simply tear and apply directly to the surface with acrylic matte medium, letting "nature" evolve.

◢ **Artist's Dictionary: Rice Paper**

Textured, handmade paper made from natural fibers ranging from thick to thin, transparent to opaque, and smooth to highly textured.

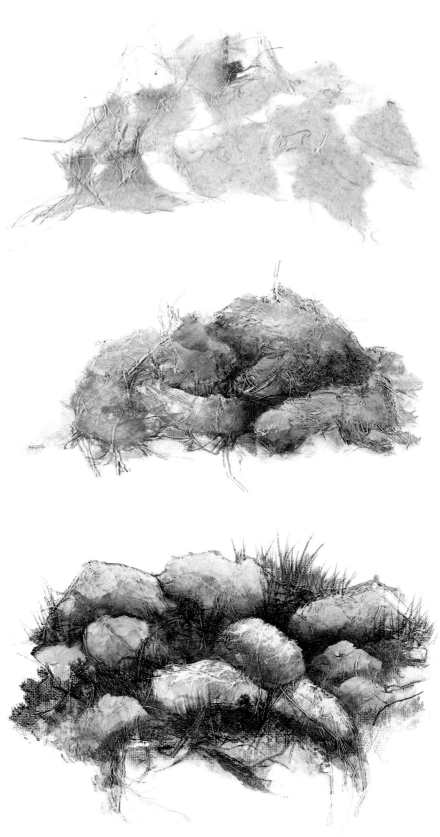

Bricks Using Resists

1. Apply liquid frisket between bricks with a liner brush.
2. Paint the bricks with a heavy wash of Burnt Sienna, Burnt Umber and Raw Sienna.
3. Blotting the wash with a paper towel or your finger adds interesting texture.
4. Remove the frisket to expose the white background.
5. Mix Ultramarine Blue and Burnt Umber for a light gray. Using the liner brush, add mortar with a light gray wash, and shadows under bricks with dark gray.
6. Highlights on top of the bricks are added with dirty white.

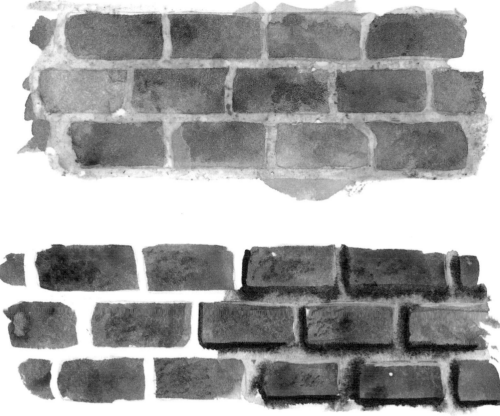

Hint

Resists can be used over a blank painting surface, or can be used to cover an area that has already been painted while subsequent layers are added. *Caution!* Remove resists as soon as possible after the paint is dry. Masking tape left on too long can damage paper when removed. Although rubber cement is sometimes recommended as a resist, it can leave a yellow stain on paper that may not show up for many months; therefore, a liquid frisket is preferable.

Artist's Dictionary: Friskets, Masks or Resists

Friskets, masks and resists are all names for materials that keep paint from adhering to a particular area of the design. Frisket paper or film has adhesive backing. Liquid mask can be rubbed off when dry.

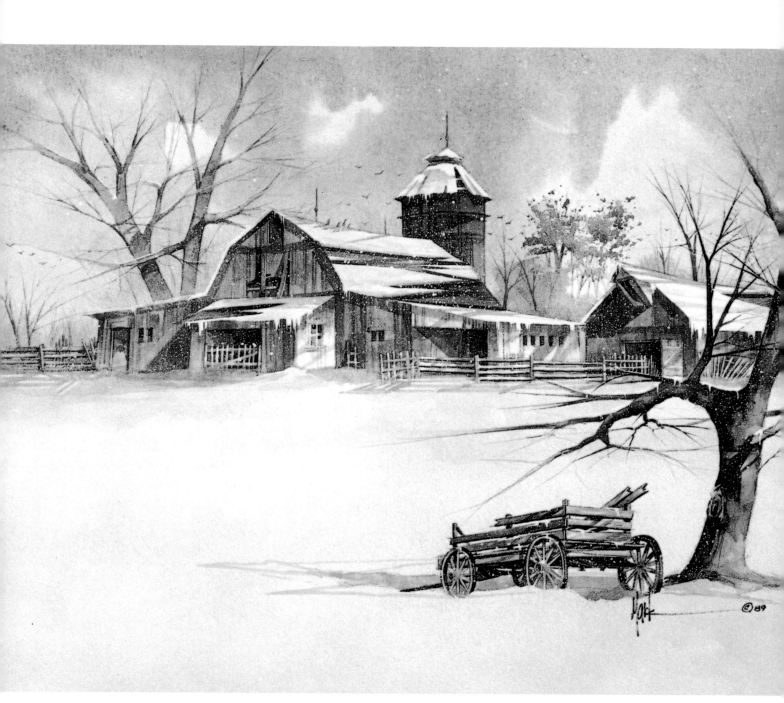

PIECES OF OLDE
20″ × 24″, mixed media
on watercolor board
Mark Polomchak

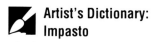 **Artist's Dictionary:
Impasto**

Thick, textured application of paint.

Snow

The technique you use for painting snow will depend on many variables, including the mood, message or idea you want to convey, the atmospheric conditions or time of day to be depicted, and the manner in which you prefer to apply paint, such as thick impasto or transparent washes. Snow reflects the sun, the color of the sky, and sometimes surrounding objects. Golden tones may be used for snow in sunlight, while blues, grays and vi-

olets make overcast snow scenes very moody.

Mark Polomchak used a transparent technique for *Pieces of Olde*, in which the painting surface, 300-lb. watercolor board, plays a very important part. Instead of painting the bright areas of snow, he let the white, slightly textured watercolor board act on its own. Wherever he wanted to save a highlight or snow-covered area, it was masked off with a liquid

mask to keep the shadow colors from bleeding over. The paint was then applied in transparent washes to achieve the various values and colors.

For the large snowflakes, Mark loaded a toothbrush with thinned white paint and hit it against his wrist onto the paper. The smaller flakes were made with the same consistency paint, which was flicked off the toothbrush with the index finger. As you can see, the mood in this painting was conveyed in many ways: a subdued palette, the method of paint application and the subject matter.

"I approach the painting of snow by first laying in broad areas of shadow with a cool gray or blue," says Michael Wheeler. "Then I paint midrange tones with the same hue lightened with white. I use bristle brushes for this. I then continue with a refining process, using both lighter and darker values than those I roughed in. I do this to define forms and textures in the snow. I use pure Titanium White for highlights and also leave some gesso showing through. I don't blend my values, but simply lay them in and allow the viewer's eye to do the blending. At various points in building up values, I also add different hues to the shadows, usually leaning toward green or purple, depending on the overall quality of light in the painting. My normal snow palette consists of Titanium White, Cobalt Blue, Phthalo Blue, Permanent Green Light, Burnt Umber, Ivory Black and Alizarin Crimson.

"Regarding atmosphere and mood, I strive for clarity and coldness in a sunny snow painting, with just a few touches of warm browns, ochres and oranges in the bark of trees and underbrush to help the viewer feel the sun."

THE HARD WINTER
20″ × 24″, acrylic on canvas
Michael Wheeler
Collection of Hammond Osgood III,
Orlando, FL

The peaceful feeling portrayed in this scene was achieved through a combination of many techniques. A relatively subdued color scheme depicts calmness. A fading of strict linear boundaries such as the lane edges and horizon line evokes a feeling of restfulness. Snow alone can produce a calm, tranquil mood.

The techniques used for snow in this painting are easy to master. Transparent washes are applied to areas that appear darker, such as: shadows; textures in the ground surface; and areas that need to be darker to make the composition work, by leading the eye in certain directions or creating frames. These darker values are made with various mixtures of Ultramarine Blue, Cadmium Red Deep, and a touch of Burnt Umber. These can be warmer or cooler depending on the amounts of red or blue added. These washes are applied very loosely, letting the paint flow and run without always using the brush to direct the flow. Notice the runs in the foreground, which create texture and interest. Once these washes are dry, I apply much heavier washes of white paint or gesso to mold the snow in lighter areas, creat-

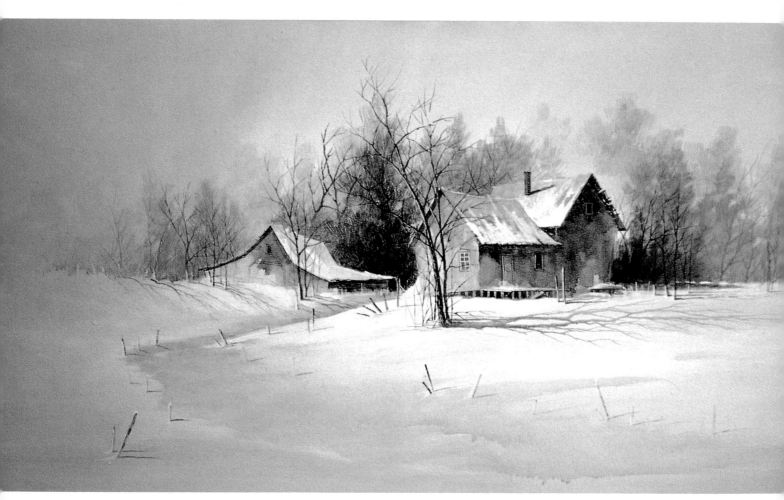

WINTER SOLITUDE
24″ × 36″, acrylic on canvas
Vicki Lord
Private collection

ing the drifts. Next I add heavy, undiluted white for highlights and snow build-up. This includes snow on the roof. Finally, I use a very transparent blue-violet-gray wash to draw my cast shadows. Occasionally, I add fly-specked snow.

"This painting was done on location on a bright, sunny day," says Joseph Orr. "Loose brushwork, thick paint, and vibrant colors convey a sense of movement. The thick, luscious paint not only creates texture, adding to the illusion of depth in the snow, but also gives the snow a reflective quality. The colors in nature appear more subdued than the finished painting. Under the artificial light, the colors became more vibrant. The cool blues and purples in the foreground help the warmth and highlights on the snow pop out, and the command of the paint put on in one or two strokes reflects a forcefulness."

SNOW ON THE LINN CREEK
12″ × 15″, acrylic on canvas
Joseph Orr

Skies

Sky and clouds are often used to balance other values for better composition. How many times have you seen a landscape where the sky and clouds are so interesting, and cover so much of the painting surface, that they become a center of interest and the painting becomes a skyscape? A simple sky can be used as a source of relief for a busy foreground. The sky should be planned from the very beginning, not added as an afterthought.

When painting clouds, you need to consider that, as they recede into the background, particles in the atmosphere veil the clouds and they become duller and cooler. Lower the intensity of the value contrast as you move into the distance. Sharper definition and more highlights will appear in the overhead sky. And remember, clouds are not just white. They may consist of a rainbow of colors.

Try watching, photographing and painting different skies for a few weeks. You will be surprised at how diverse in color, light and shape they can be.

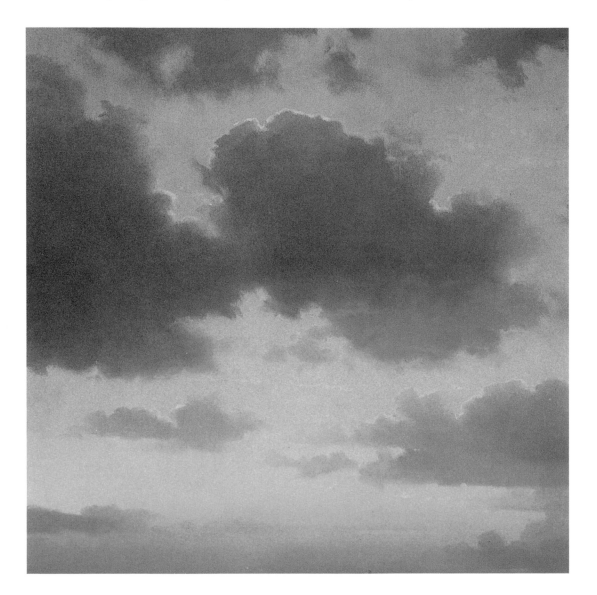

Cirrus Clouds

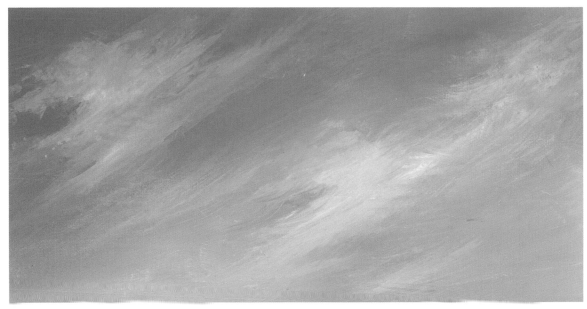

1. Blending Values

Apply darker background values to the sky. While the background is still wet, with the fan brush, blend white or a light value into the areas where the clouds will be added. As you apply the white you will be setting up the base for cloud shapes. Keep in mind that cirrus clouds are wispy, feathery bands across the sky. Avoid harsh lines!

2. Adding White

Working on one cloud area at a time, tap white paint onto the thickest and lightest part of the cloud. Then, with the fan brush, very lightly "wisp" the side edges of the cloud formations. Also, very lightly wisp the bottoms of the clouds to avoid definite lines. This step can be done several times, letting each layer dry before applying another, until the desired effect is achieved. I usually add white to the thickest part of the cloud several times.

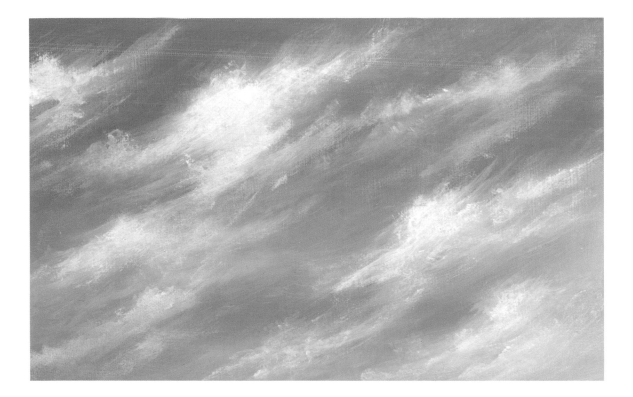

Cumulus Clouds

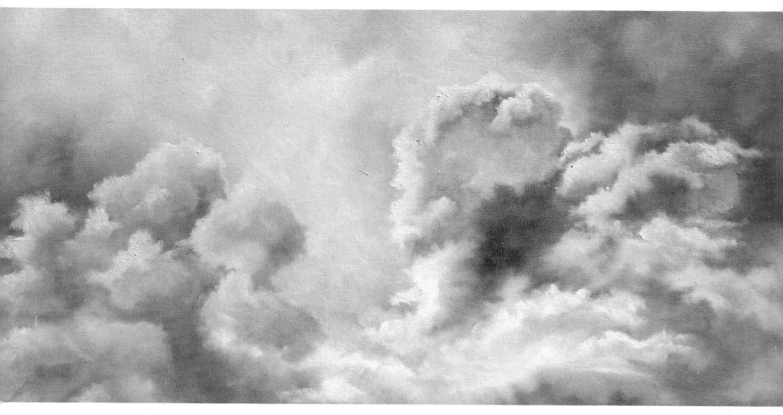

Cumulus clouds can be easily applied with a fan or filbert brush, or with your fingertip. Be sure to let each layer of paint dry before proceeding to the next. Remember to work in small areas so drying does not cause problems.

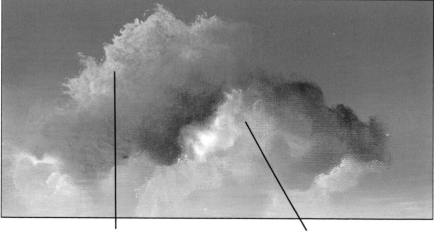

fan brush and water

fingertip smudges with very little water

1. Blending and Fading

After applying a background basecoat, apply dark colors first, blending and fading out with your finger, or with a clean, damp fan brush. Apply lighter areas over the edge of the darker colors using the same technique.

2. Middle Values

Add washes in middle values, accent colors, lights and darks to deepen shadow areas, blending or fading with the same technique used in step 1.

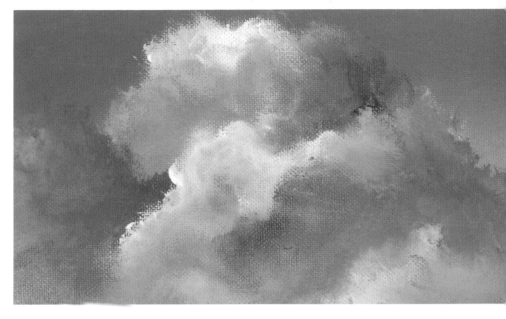

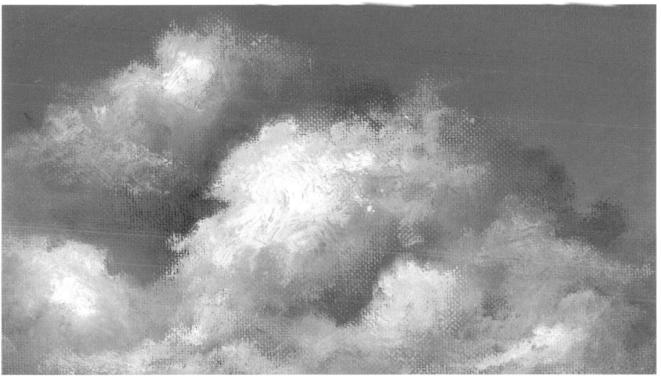

3. Building Up Layers

Add very light values to make the highlights on the clouds pop out. Once this is dry, add more accent colors, lights or darks as needed. As you can see, many layers can be used to build realistic clouds.

Animal Fur

Fur is easy to paint if it is broken down into steps. First comes the basecoat step, in which you begin to set up value changes. This defines shapes and planes of the animal's body. The distance from the subject determines the next step. If the animal is somewhat distant, you need only to continue defining the value changes for more detailing. If the subject is close, then you need to add more detailed fur. There are many techniques for adding fur to a basecoat. The following demonstrations will show you many combinations with which to experiment.

THE CHALLENGE
18" × 24", mixed media on canvas
Vicki Lord
Collection of Ducks Unlimited

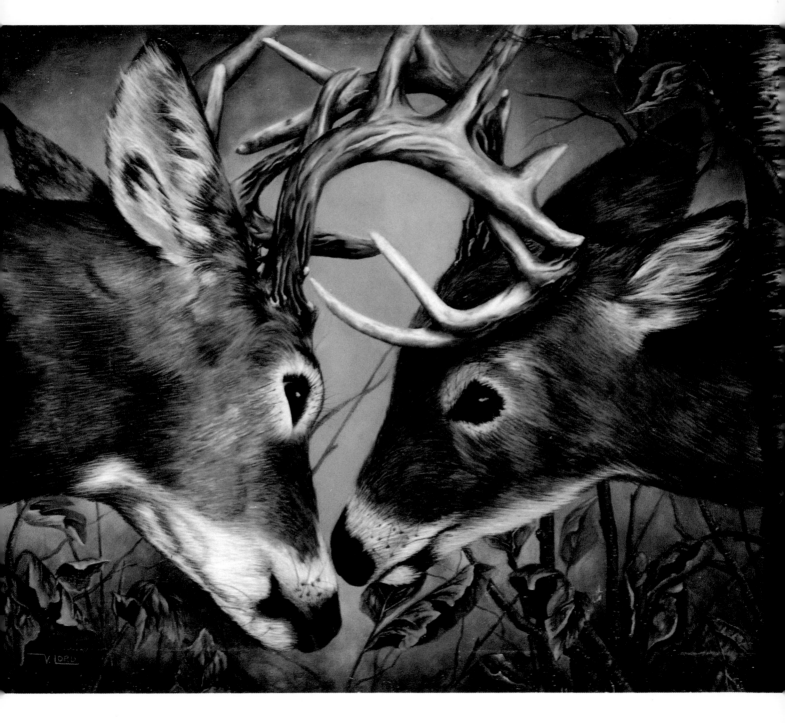

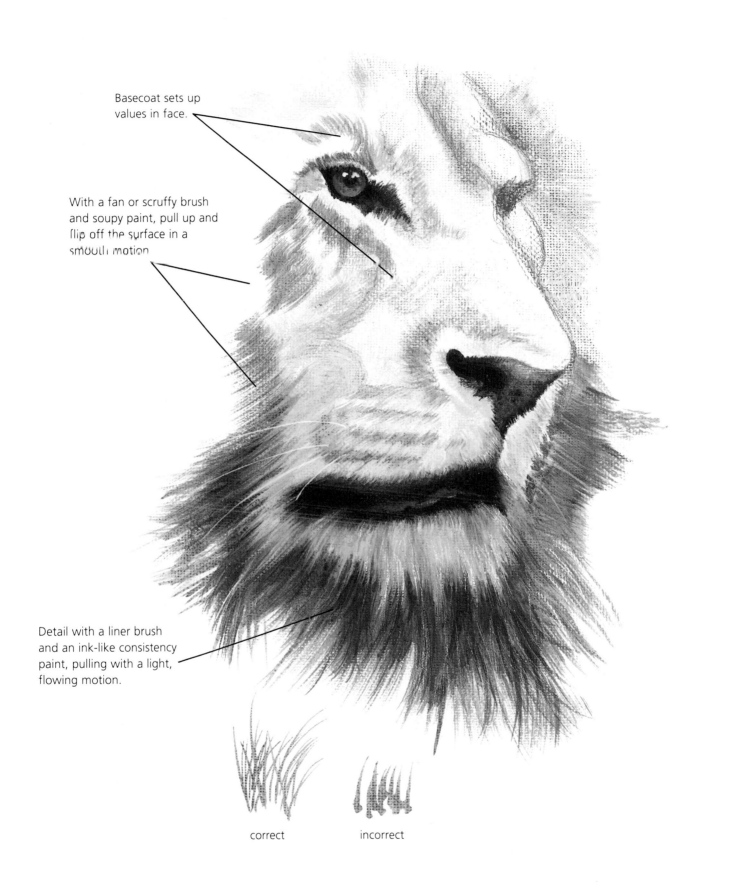

Basecoat sets up
values in face.

With a fan or scruffy brush
and soupy paint, pull up and
flip off the surface in a
smooth motion

Detail with a liner brush
and an ink-like consistency
paint, pulling with a light,
flowing motion.

correct incorrect

Fake Fur

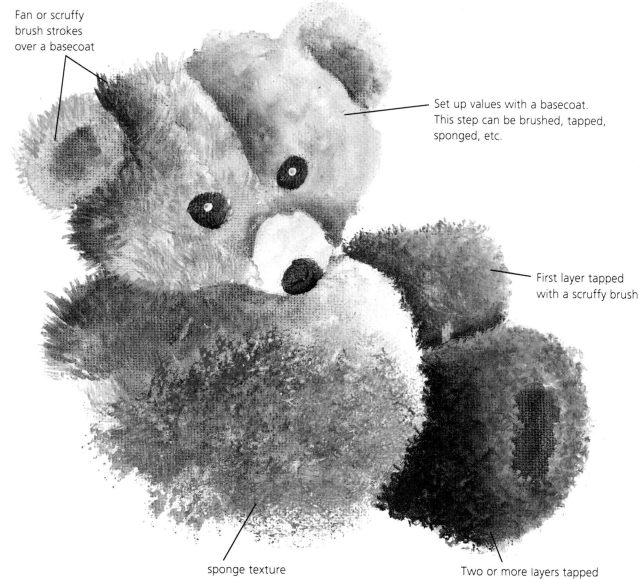

Fan or scruffy brush strokes over a basecoat

Set up values with a basecoat. This step can be brushed, tapped, sponged, etc.

First layer tapped with a scruffy brush

sponge texture

Two or more layers tapped over a basecoat

Scruffy Brush

Apply a basecoat, being sure to set up the values as you paint. When the basecoat is dry, dip a very ragged brush, with the hairs spread apart, into the paint, and tap it on the surface. As with the sponge technique, be sure to keep moving the brush in different directions to avoid setting up a pattern.

Sponge

Tear a household sponge to create very ragged edges, or use a natural sponge with a very irregular edge. Dampen the sponge and squeeze out excess water. Lightly tap the sponge into the paint. Then tap it on a practice surface to get out excess paint. When applying the paint to the painting surface, be sure to keep moving the sponge in all directions while tapping, so that a pattern of sponge marks does not emerge.

Hint

Using more water and fewer layers of paint gives a softer, watercolor effect to the painting. Less water with more layers of paint renders a heavier, oil-like effect.

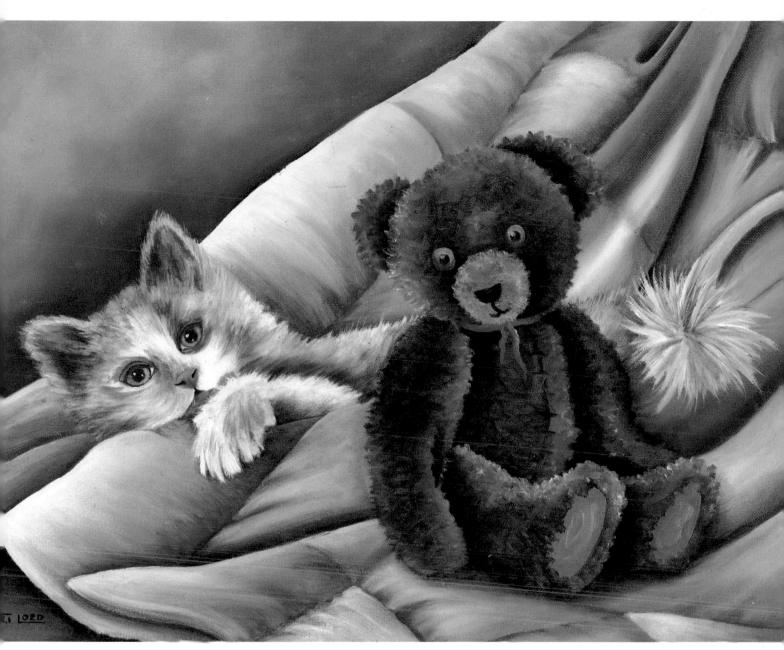

PLAYMATES
12″ × 16″, acrylic on canvas
Vicki Lord

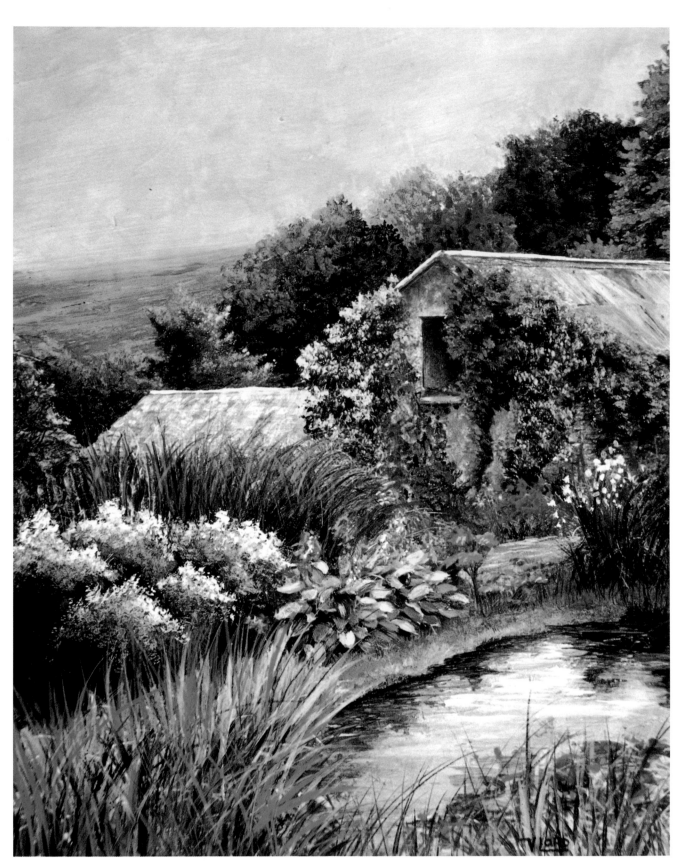

L'ÉTÉ GRANDIT
16″ × 20″, acrylic on canvas
Vicki Lord

Chapter Four

DEMONSTRATIONS

Each of the following paintings expresses a mood, captures a feeling or communicates an idea through color and composition. Each artist has used acrylics differently, not only technically, but expressively. Each painting is broken down into steps so that you can see how they are constructed. Each painting is put together with many techniques. Once you have learned these, you can use them in a variety of expressive ways to create your own exciting designs. Painting is a never-ending process of exploring and learning new techniques.

There is no "one way, and only one way" to paint. You will discover that your own creative gifts add a personal stamp to your work. Al Brouillette says, "Opinions of others won't help you much when you are confronted with your own artistic reality." What works well for others will not always work well for you.

Layering Washes on Canvas

Background Basecoat

The medium value at top is very pale blue-gray made by combining white with just a touch of an Ultramarine Blue and black mixture. Lighter value at bottom is white added to the medium value. Apply medium value to top of canvas, adding the light about halfway down. Work quickly, as acrylic dries quickly. When background is dry, sketch design over it.

Tree

Dark value is a mixture of Burnt Umber and Ultramarine Blue, which makes a warm black. Mediums are Burnt Umber and Burnt Sienna. Light is white with touches of Cadmium Red Light and Cadmium Yellow Light, to make a very pale peach. Refer to page 52. Use very thin paint so that it runs down and helps form the ground area.

Basket

Dark values are Burnt Umber and black. Mediums are Burnt Umber and Burnt Sienna. Lights are Yellow Ochre and medium values, with more water added for transparency. Basecoat basket with transparent washes of above colors, just setting up the values.

Grass

Dark value is a mixture of Olive Green with a touch of black. The light value is a mixture of Olive Green, white and Cadmium Yellow Light, for a very light yellow-green. Around basket sides and tree roots, pull up some grass, referring to page 48 for instructions.

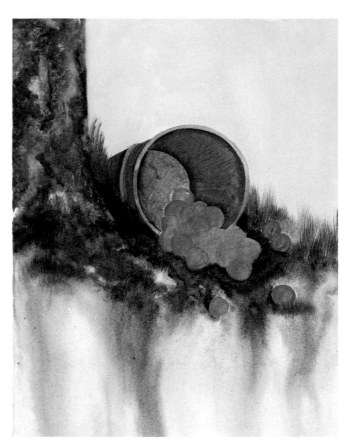

correct

incorrect

Abstract Ground Area

Colors used for the ground area are Burnt Umber, dark-value grass mixture, and a few touches of the medium-value apple mixtures discussed at right. Apply thin, soupy paint to top of ground area, adding water so that the transparent paint begins to run down the canvas. Add more water to the sides and bottom of the runs to help them along, and direct their flow by tapping the brush on the bottom of the runs, and lead-

ing them in the desired direction. They should flow together softly, fading out at bottom.

◢ Artist's Dictionary: Accent Color

A small amount of contrasting color used against another color, such as a green accent in a predominantly red area.

Highlight

The lightest value on a subject.

Apple Details

1. Basecoat

Basecoat the apples with medium-value mixtures of Cadmium Red Medium, Burnt Sienna and Cadmium Red Light. Vary each apple slightly by using more or less water to change the value, or change the amount of each color in the mixtures.

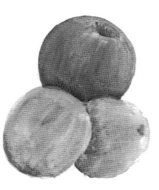

Hint

Anything covered with unwanted stray brush marks, such as grass over apples, can be filled in with gesso and allowed to dry, so that a clean white surface can be used for transparent washes.

2. Darkest Values

Start laying in the dark values with various mixtures of Alizarin Crimson, Cadmium Red Medium, Cadmium Red Light, Burnt Umber and touches of Olive Green. Apply the darkest values in the deepest shadow areas and fade these colors out with water to avoid harsh edges. Add a dark area with Burnt Umber and Olive Green where the stem is located. Fade this out on the back side, leaving the front edge a harsh line.

3. Darks and Lights

Deepen the shadow areas, where needed, with another dark-value wash. When one apple sits behind another, a shadow appears on the back apple where the two meet. Make sure that shadow is faded out gradually. Start adding some lighter values with Cadmium Red Light, Cadmium Red Medium and touches of yellow and white. Make sure that the harsh line on the front edge of the stem well is light.

4. Highlights and Accents

If necessary, continue to deepen shadows and add more light values. Then place highlights and accent colors with very light yellow-green and light yellow mixtures of white, Cadmium Yellow Light and occasional touches of Olive Green. It is important that the front edge of the stem well is highlighted to help define the shape of the apple. Add the stem with Burnt Umber.

Hint

Proper shading and highlighting, along with brushstrokes that follow the contour of the apples, will help them appear more rounded. The basic steps shown here can be applied to many types of fruit.

Basket Details

1. Shadows

Add washes of Burnt Sienna and Yellow Ochre to the sides and bottom. Place dark-value washes where the shadows are deepest, fading them out with water. Start defining the boards in the bottom of the basket by adding different medium-to-dark-value washes, filling in the dark recesses between the boards with Burnt Umber and a touch of black.

2. Defining Boards

In the bottom of the basket, give the boards more depth and separation by shading any that are beneath another board. This is done by placing a dark-value color on the bottom board where the two boards meet, and fading it out along the board with water. Add another transparent wash of Burnt Sienna and/or Yellow Ochre to the sides and to some bottom boards.

Finishing Details

The final step for the basket can be seen in the finished painting. If necessary, further deepen shadows and define boards with subtle washes of color. Highlight the rim of the basket with a very light value mixture of Burnt Umber, Yellow Ochre and gesso.

Add blades of grass with the liner brush, using the dark and light grass mixtures. Add some twigs at the side of the tree, using the liner brush and Burnt Umber. Keep them scraggly. If necessary, add more runs at the bottom of the canvas for more color, or to fill in blank areas. In my finished painting, I added some runs with a mixture of white and a touch of sienna. If you decide to do the same, make sure you mix an off-white, or dirty white, not peach.

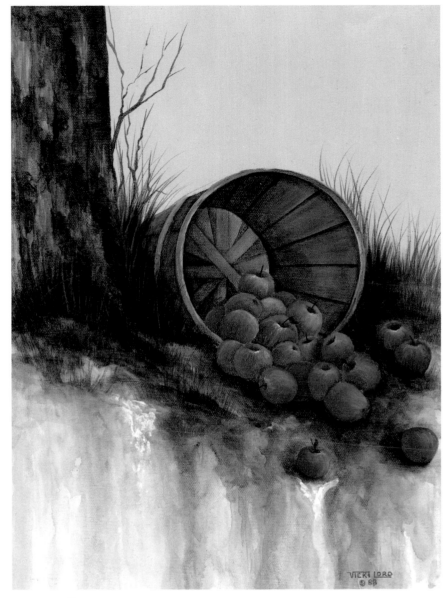

RED DELICIOUS
16″×20″, acrylic on canvas, Vicki Lord.

Watercolor Techniques Using Acrylics

1. Background

After making an initial sketch, wet around the white flowers and leaves. Take your time, working carefully. Wet only the areas that you want painted. Dab color onto the wet surface right next to flowers and leaves, letting it soften outward, away from them.

Raw Sienna Cobalt Blue Alizarin Crimson

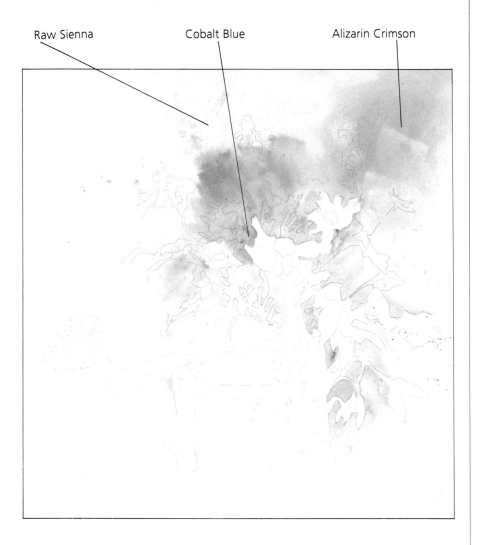

Tips for Success

This demonstration is painted on 140-lb. cold-pressed watercolor paper. Painting on watercolor paper is great fun, although the surface is more absorbent than canvas. Here are a few basic rules for success when painting on watercolor paper.

Mixing Washes

How much water should you mix into your acrylic? For transparent color, use mostly water with a little paint. For opaque color, use mostly paint with a little water. Test your color on a piece of scrap watercolor paper.

Dry or Wet Paper

Watercolor paper can be used either wet or dry. When paint is applied to a dry surface, it has a sharp edge and remains exactly where you put it. Paint applied to a wet surface blurs and spreads outward. How much it spreads depends on how wet the surface is. If the surface is very wet, the paint "explodes" outward. If the surface is less wet, the spreading is also less.

You can wet an entire sheet of paper, a large section of paper, or an individual area within a painting. When wetting a large portion of the paper, use a large, flat brush and long, swift strokes.

Blending

The edge of a wet color can be blended or softened by stroking it with a damp brush. An edge cannot be softened after the color has dried.

2. Negative Painting

Making sure the paper is dry before you start, paint the background behind and around some of the leaf and stem shapes, rather than painting the leaves and the stems themselves. Use a small brush and paint carefully.

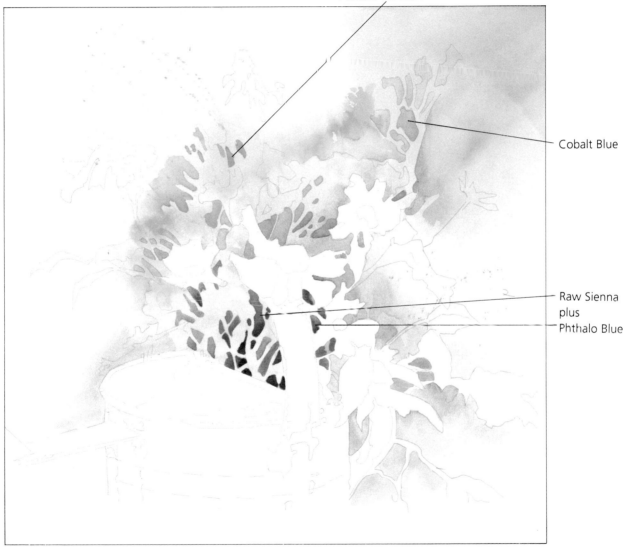

Alizarin Crimson

Cobalt Blue

Raw Sienna plus Phthalo Blue

 Artist's Dictionary: Negative Painting

Forming an object by painting the background around it, rather than painting the object itself.

3. Flowers and Leaves

To mix colors together softly but not completely, which causes more of a flat, even look, wet the paper, then dab on the individual paint colors letting them run together. For example, Alizarin Crimson and Burnt Sienna have been applied this way at upper left.

4. Watering Can

Use Cobalt Blue and Burnt Umber to shade the watering can. Wet the entire side of the can. While the paper is still shiny, stroke the shade mixture down the side and around the top. Let the color soften outward. It is OK to push it with a brush if you want to. Let this dry completely.

Paint one ridge at a time, wetting the ridge, then touching on a small bit of color. Soften and pat the color lightly with your brush.

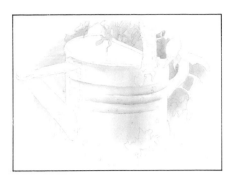

Burnt Sienna and Alizarin Crimson floated on wet paper

Burnt Sienna

Raw Sienna plus Phthalo Blue

Cadmium Yellow Light, Phthalo Blue, and a touch of Burnt Sienna

Raw Sienna

5. Finishing Touches

When dry, finish the watering can as indicated below. Then wet the grass area of the paper until it is shiny. Softly float the base wash. Let the paper dry. When completely dry, pull up some grass, using the brush that works best for you. Don't try to make the grass too dark too fast. It will look better if you build it up, letting each layer dry before applying the next. There are three layers of color in this example. Add longer grass with a liner brush.

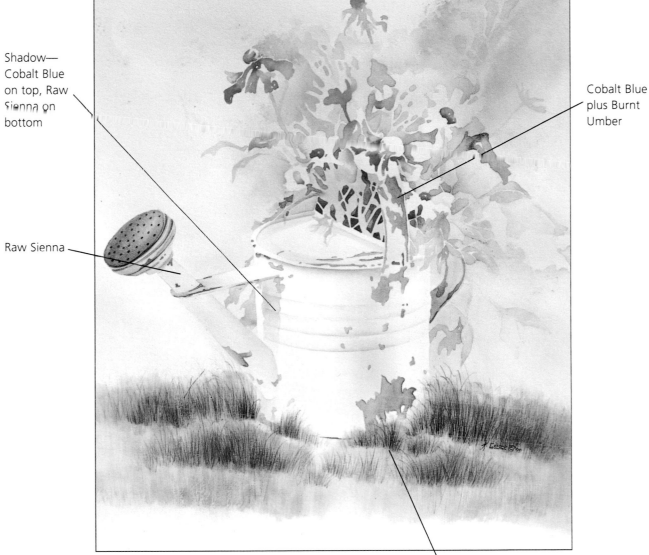

Shadow—Cobalt Blue on top, Raw Sienna on bottom

Cobalt Blue plus Burnt Umber

Raw Sienna

Grass—Cadmium Yellow Light, Phthalo Blue, touch of Burnt Umber

WATERING CAN
22″ × 24″, acrylic on watercolor paper
Kathie George

Using Collage in a Landscape

Collaged papers can enhance the surface of your painting, making it much more exciting, or help reclaim unsuccessful paintings. If you've wished a stroke could be erased, this technique is great.

Many different papers can be used for collage. For this particular painting, you will use oriental rice papers. There are various types of oriental papers. Some are thin and transparent (such as Kinwashi and Unryu), while others are quite thick (for example, Oguru). Thicker papers are used to form definite shapes, as well as to cover or change something. Thinner, more transparent papers are used to make a smooth transition from the thickest paper, which is collaged first, back to the background surface.

Artist's Dictionary: Collage

The process of pasting various materials on a picture surface; may be combined with paint.

1. Basic Underwash

Wet a sheet of cold-pressed watercolor paper (about 15" × 22") until shiny, then apply a light base of color. Simply suggest the general shape of things by moving your brush vertically where the trees and rocks will go, then sweeping across horizontally to suggest the horizon. Don't be too concerned with this step! It is just a color base on which to build the painting. Much of this step will be covered up with collage. Let this step dry thoroughly.

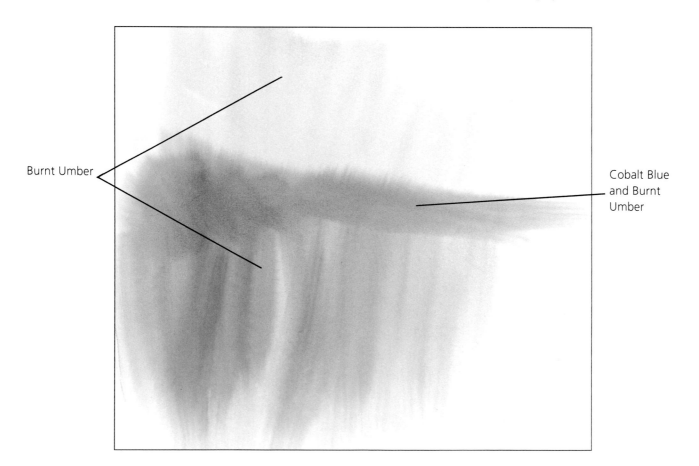

Burnt Umber

Cobalt Blue and Burnt Umber

2. Trees

Wet the entire top half of the paper, from the horizon line up, until it is shiny. Use a large brush to float a wash of pale Cobalt Blue onto the sky. Rinse the brush and begin floating on the tree colors, stroking *downward* from the top of the treeline, filling in the entire area. Let this dry thoroughly, then add depth by using texture and detail. Begin by dry brushing with a flat brush. Dip just the tips of the hairs into the color and lightly drag them across the surface of the dry paper. Using a liner brush, add a few tree trunks and limbs poking in and out of the background colors. Some trees will be totally visible, while others will just peek out.

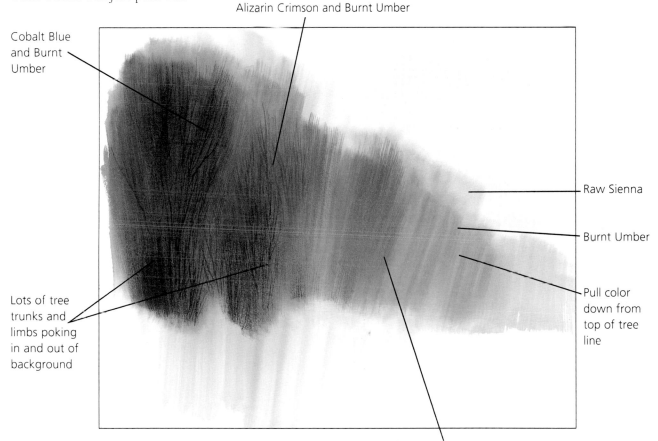

Alizarin Crimson and Burnt Umber

Cobalt Blue and Burnt Umber

Raw Sienna

Burnt Umber

Pull color down from top of tree line

Lots of tree trunks and limbs poking in and out of background

Dry brushing on dry base color

3. Collaging Process

Ready to collage? Beginning at the horizon, use torn scraps of 140-lb. watercolor paper with white glue to form a definite rock ledge that covers any unwanted color in that area. Use white glue only for the 140-lb. watercolor paper. For all of the other papers, use a mixture of one part acrylic matte medium to one part water.

Tear oriental rice papers into strips approximately 3″ × 6″. You can tear smaller pieces later if needed, and layering or crossing several smaller pieces, rather than just laying on one big piece, does produce a nice effect.

The second paper used should be the next thickest (Oguru, perhaps). Use an old brush to apply the matte medium mixture to the painting surface. Tear pieces of the rice paper and place them just over the lower edges of the 140-lb. watercolor paper, and down a bit onto the surface, over the medium. Add another layer of medium on top, sealing the paper between two layers of matte medium mixture. Using the same brush, flatten the edges of the torn pieces and work out any bubbles, adhering the paper firmly to the surface. Finish the rest of the rock surfaces in the same manner, using thinner (perhaps Kinwashi) papers.

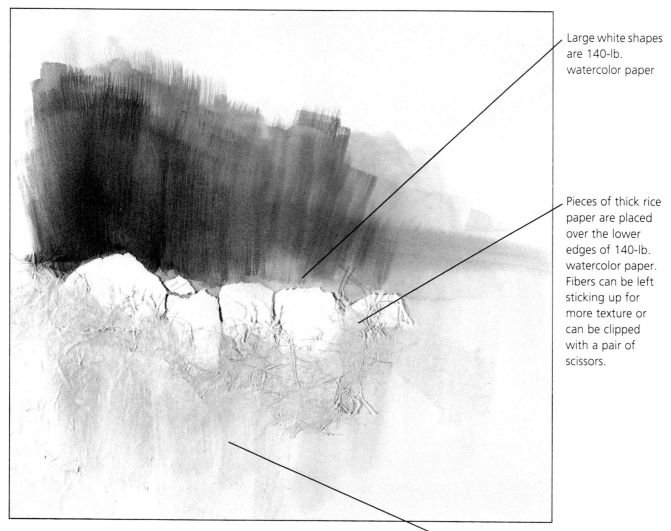

Large white shapes are 140-lb. watercolor paper

Pieces of thick rice paper are placed over the lower edges of 140-lb. watercolor paper. Fibers can be left sticking up for more texture or can be clipped with a pair of scissors.

The thinner paper is placed along the bottom of the thicker paper. There is a smooth transition from the thickest paper at the top to the original surface at the bottom.

4. Rocks

Since the collaged surface is not as absorbent as the original surface, it is necessary to use small amounts of color mixes in order to have control over it. However, should you put color where you don't want it, simply collage another layer on top! Paint the rocks one at a time, using only a drop or two of color mixture in your brush.

Colors can be gradually intensified, and darks can be added where necessary. The cracks in the rocks should be painted with a liner brush and a dark mixture of Cobalt Blue and Burnt Umber. Along the horizon, it works really well to tuck this dark in between the edges of two torn pieces of paper.

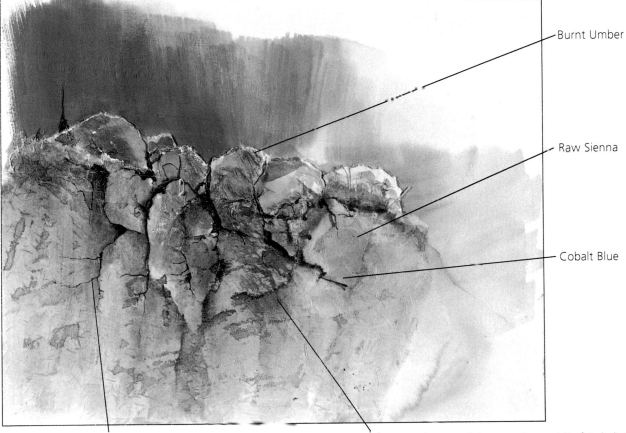

Burnt Umber

Raw Sienna

Cobalt Blue

Paint all cracks on dry paper with Burnt Umber and Cobalt Blue.

Dampen the paper here, and then touch on a bit of Cobalt Blue and Burnt Umber. Let it soften out, patting it with your brush if it needs help.

5. Finishing Details

Pastels are great for adding extra color to your collage. Enhance your rocks using black first, then adding blue on top. Blend slightly with your finger.

Paint tree trunks and limbs with a mixture of Cobalt Blue and white, or try a blue pastel.

Would you believe that under this tree shape is a large ugly evergreen? I collaged over it, painted it with a wash of color, then followed up with dry brushing. Now it's just one of the guys!

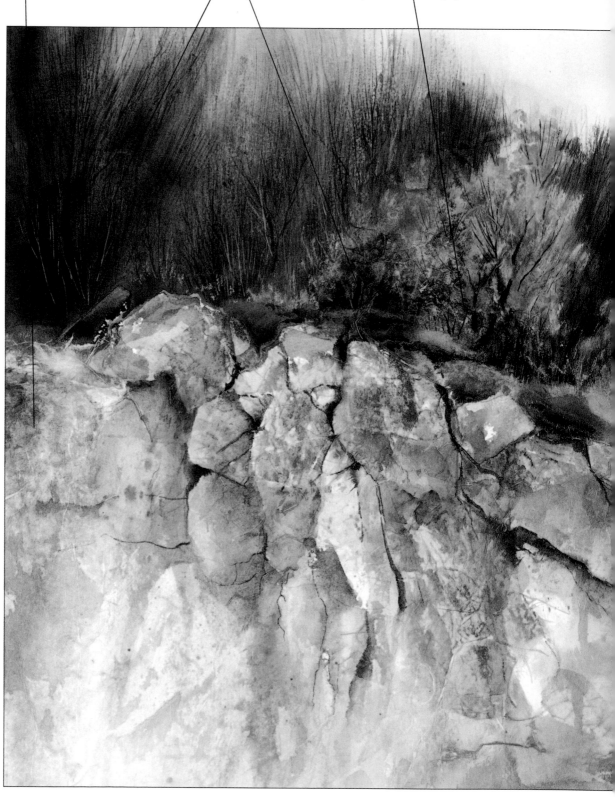

Use pastels to help soften the edge of a tree.

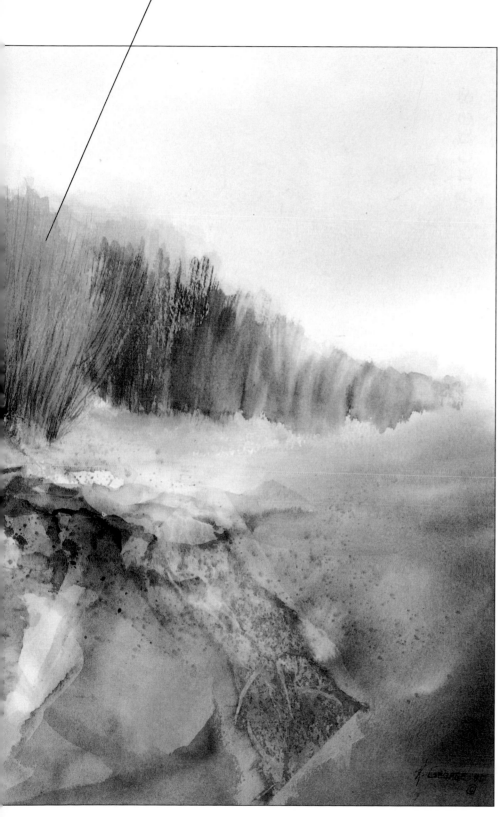

VIEW OF THE RIDGE
15″×22″, acrylic on watercolor
paper
Kathie George

Dry-Brushed Acrylics on Colored Paper

This portrait was painted with bottled craft acrylics on colored drawing paper. A dry-brush technique can be used to get a "sketched with pastels" look, using the acrylics full strength from the bottle and literally scrubbing the paint onto the paper. It can also be used to shade and highlight, letting the background paper color show for a medium value. Controlled washes can be used to glaze some areas, while other areas can be painted opaquely to completely block out the color of the paper. For a more blended look, use a basecoat, then add controlled washes.

Good brushes for this technique are royal sables, as well as any good stiff badger- or mongoose-hair brushes. Old, stiff scruffy brushes are also excellent.

Practice the various techniques to become accustomed to using acrylics on the porous surface of the paper. It is different, fun and easy!

1. Establish Values

Draw the subject onto the rough side of the gray-brown paper with a chalk pencil, establishing only a few lines for the features and planes of the face. Set in the darks with a dark brown acrylic around the features and the darkest parts of the hair. With an off-white color, paint the shirt, using a dry-brush technique to create the various values by letting some of the paper show through.

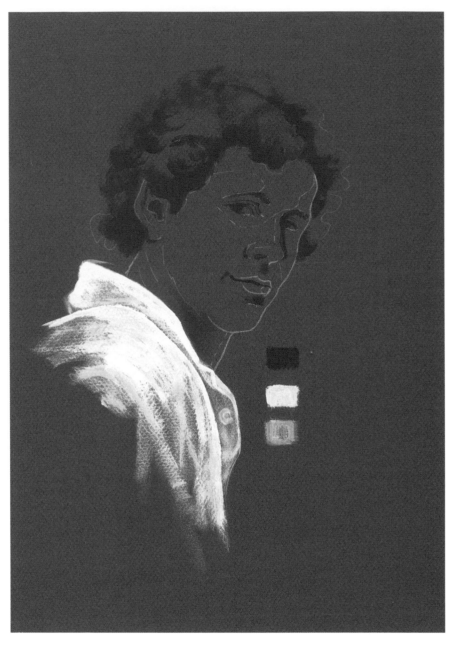

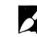 **Artist's Dictionary: Dry-Brush Scrubbing**

Load a dry brush with full strength paint. Wipe the excess on a paper towel. Apply the paint with a scrubbing motion. Test on a piece of scrap paper for the desired effect. Dry brushing is often used to blend or fade edges into the background.

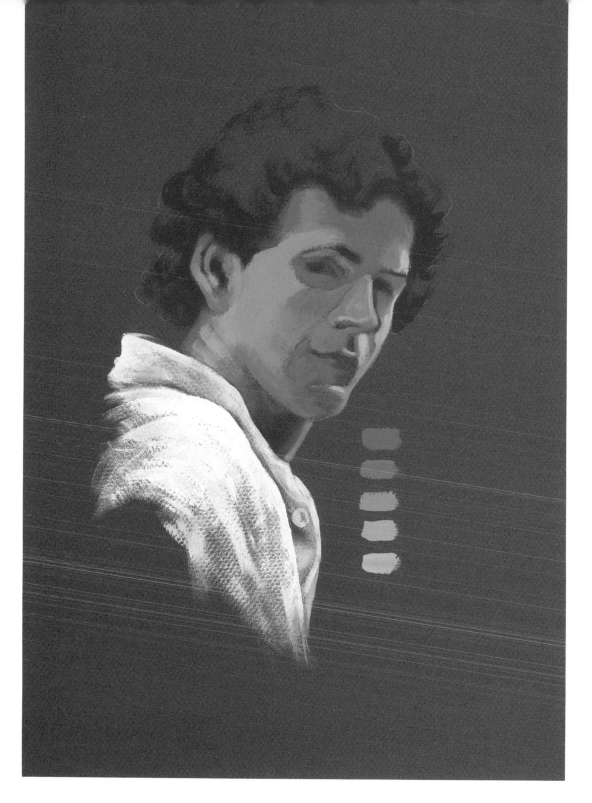

2. Block in Skin Tones

Block in large areas of flesh color, using several values to establish planes on the face and neck. Pay attention to the pattern of lights and darks on the face and stay consistent with the light source.

Hint

Test colors on scrap paper of the same color as the project surface. A particular color may not look the same painted on one color as on another. The background color affects the appearance of the applied acrylic.

3. Develop the Head

Refine the flesh, making some areas more opaque. Drybrush to soften edges. Use controlled washes to glaze with red, red-orange and medium browns. Add reddish brown to the hair; paint the lips with red tints; define the eyes and eyebrows with a darker brown. Don't make the whites of the eyes too bright if they are shaded.

Hint

Take care to protect the background from drips, spills and other accidents. Such marks *cannot* be removed or covered up easily.

4. Finishing Touches

To complete the portrait, soften the skin tones with more mid-values, using the dry-brush technique. Add highlights on the nose and the side of the face closest to the light source. Highlight the hair with dry-brushed strokes of light brown and flesh tones. To make the pattern of light seem more dramatic on the face, paint the very darkest colors in the background, using washes and dry brushing.

Artist's Dictionary: Controlled Wash

1. Using the size brush appropriate to the area to be covered, mix clean water and paint on the palette until the desired transparency is achieved. Mix well, until all the paint is thoroughly dissolved in the water.
2. Rinse the brush until clean.
3. Blot the brush on dry paper towels.
4. Saturate the brush with the prepared wash.
5. Touch the tip of the brush or the edge of the ferrule to the damp paper towels, drawing out the excess moisture. This is very important.
6. Apply the wash.

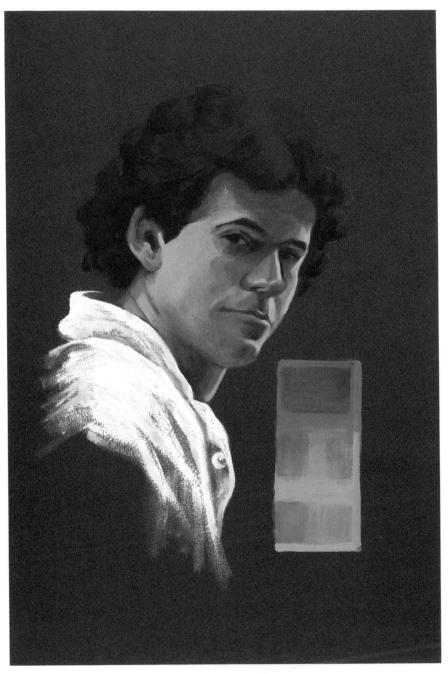

▶

DAVID
10″ × 15″, acrylic on colored paper
Maureen Schultz

Transparent and Opaque Techniques

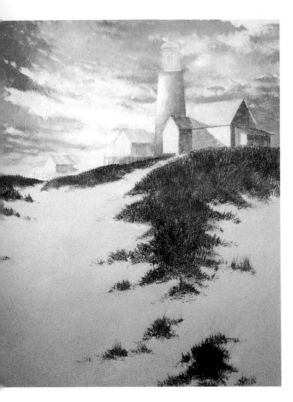

1. Sky, Ground, Buildings

Apply lightest mixtures first, then add darker areas. The lightest sky area is a mixture of white gesso, with a very small touch of Cadmium Yellow Light. Light blue area is a mixture of white gesso plus a touch of Ultramarine Blue. Dark blue area is a mixture of white gesso, Ultramarine Blue, and touches of Acra Violet and Burnt Umber. Pale peach area is a mixture of white gesso with touches of Cadmium Orange, Cadmium Red Light and violet.

The ground area is a light blue-violet-gray mixture made with white gesso, Ultramarine Blue, a touch of violet, and a small touch of Burnt Umber.

The dark sides of the buildings are shaded with the same blue-violet-gray mixture used in the ground area, applied as a wash. When dry, add a second wash to the darkest shadow areas, using a darker value blue-violet-gray made with less gesso. Light sides are a mixture of white gesso plus a touch of Cadmium Orange to make a very pale peach wash. The two small buildings in the distance are a lighter value to make them recede. Therefore, more gesso is added to the mixtures and applied in a thin wash. The roof in the main group of buildings is a very pale mixture of gesso, with touches of orange and yellow. Shade with a wash of blue-violet-gray. Keep in mind that light is from the left.

Brush mix colors for the grass— Ultramarine Blue, Burnt Umber, Permanent Green Light and a touch of Cadmium Red Light—for interesting variations, and apply as a transparent wash.

2. Buildings and Ground

The shadows under the roof as well as the windows, doors and pilings are the dark-value blue-violet-gray. The red band around the lighthouse is a mixture of Cadmium Red Light, Burnt Sienna and white gesso.

Add a second coat of transparent wash to the grass using the same colors as in the first step. Leaving some see-through areas, vary the colors and values. The light areas of the sand are a mixture of gesso plus a touch of Cadmium Orange. The shadow areas around the grass are the medium-value blue-violet-gray wash.

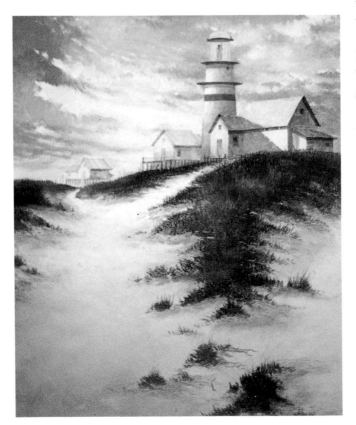

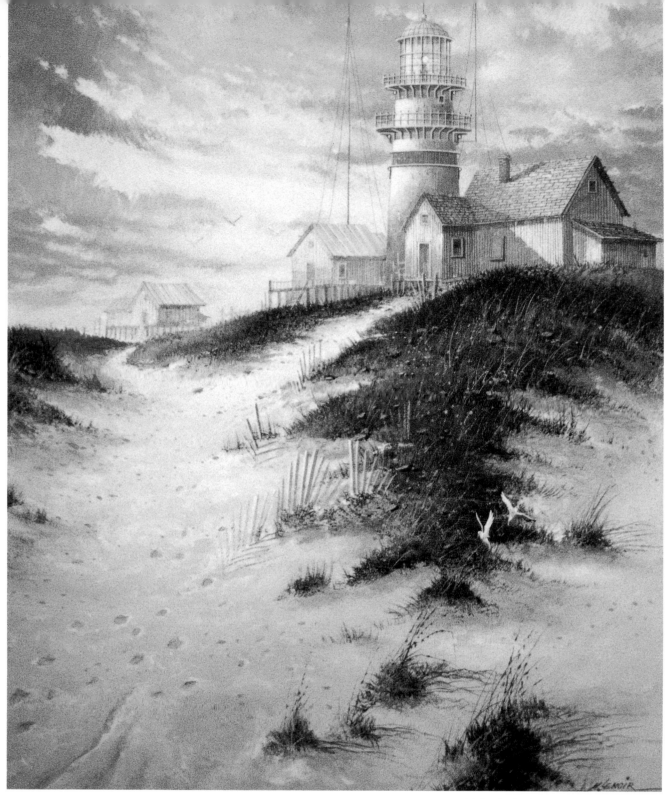

3. Finishing Details

Basecoat the birds with gesso and add shading with blue-violet-gray. Add a touch of Cadmium Orange to the beaks.

The light value of the fence posts is a pale peach mixture. The dark value is the dark blue-violet-gray, as are the antennas, railings and shingles. Pull up blades of grass and weeds from the existing grass with a liner brush. Flyspeck the foreground with the blue-violet-gray mixtures.

DAWN AT LIGHTHOUSE BEACH
16″ × 20″, acrylic on canvas
Milton Lenoir

Blending Acrylics

Leave areas where a highlight occurs blank or very light.

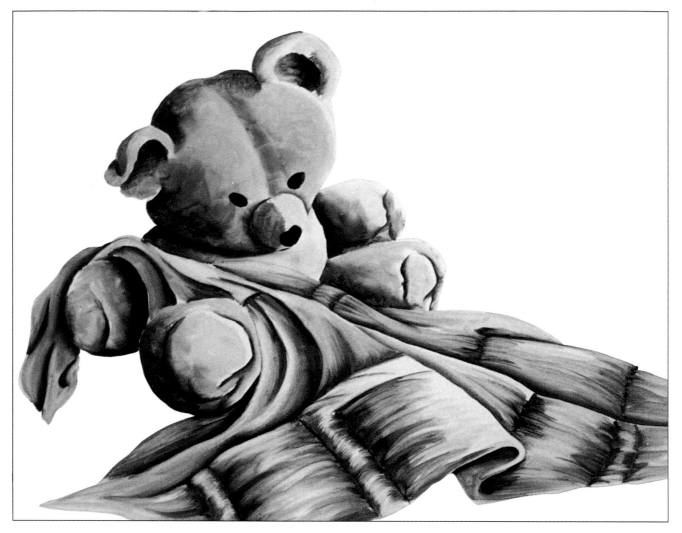

1. Value Painting

A value underpainting can be very helpful, acting as a map for value changes when you apply color. Using a dark shadow color and water, paint a value sketch. Brush in the dark areas, adding water to make the medium values. The more water you add, the more transparent and lighter in value the paint becomes. This stage is very much like painting with watercolor. White is not used. A graded wash works well to get a nice transition from dark to light.

Paint the quilt with darker values in the crevices and folds.

Dark and light values create three-dimensional shapes without the use of color.

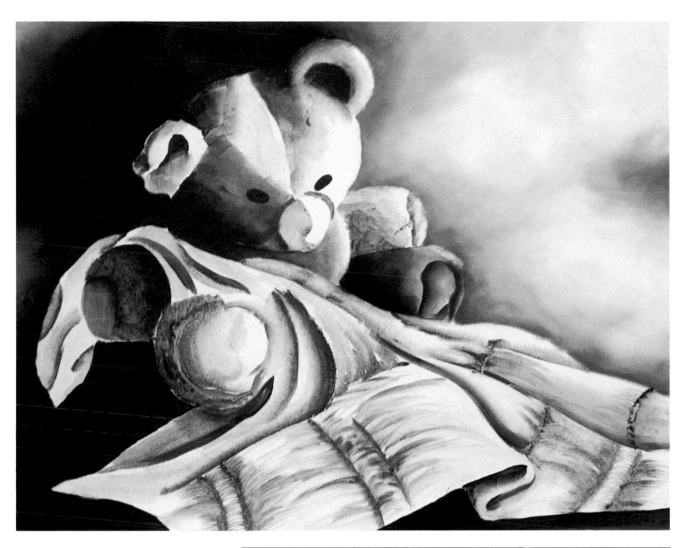

2. Background and Base

Paint the background quickly and loosely, using a large brush. Use a cold dark Ultramarine Blue mixture for the darkest area, adding white for the lighter values, and Cadmium Red Medium with white for the accents. The paint needs to be thick, with less water than you used for value painting. Solid coverage is important. Extender can be added to the paint to help lengthen the drying time.

Teddy is painted with one of the fake fur techniques shown on page 72. Choose the one that is easiest for you.

Hint

Keeping the acrylics moist and blending quickly enough to get a nice soft background can take a little practice. If you start by applying paint in the middle of the canvas, you will need to blend in two directions. Keeping the paint moist on both sides can be a problem, unless you paint with both hands at one time. Starting in the lower left corner and working clockwise around the canvas will allow you to always be working on one area and in one direction.

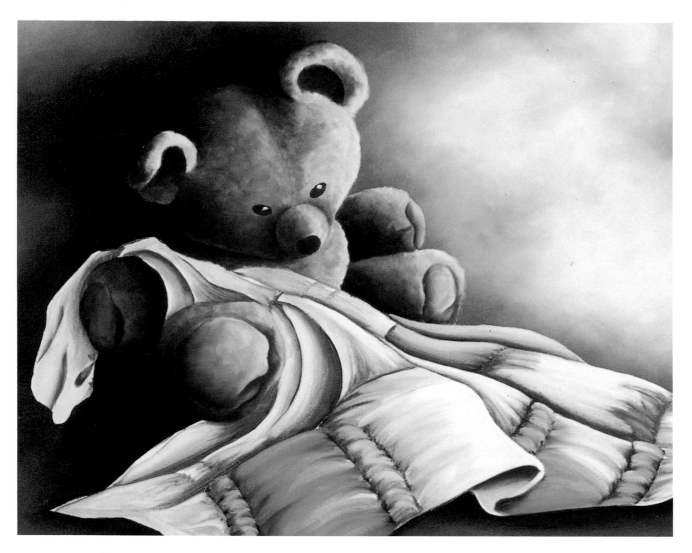

3. Basing the Quilt

Choose your quilt square colors. Shown here are the same colors that were used in the background, adding Cadmium Yellow Medium. Mix medium, dark and light values for each color with the medium value as the base color. The dark values here are the base colors plus cold dark. Lighter values are made by adding white to the base color.

Paint quilt brushstrokes in the direction that the fabric lies. This helps to create a three-dimensional effect. Apply dark and medium values, blen-

ding them together as you go and letting the dark underpainting show through slightly, helping you set up the shadow areas.

Paint Teddy's nose and eyes with a mixture of Burnt Umber and Ultramarine Blue. This creates a very nice black; you can control how warm or cool it becomes by varying the mixture. Put white highlights in the eyes by dipping the tip of the brush handle in white paint and tapping it lightly on the eyes.

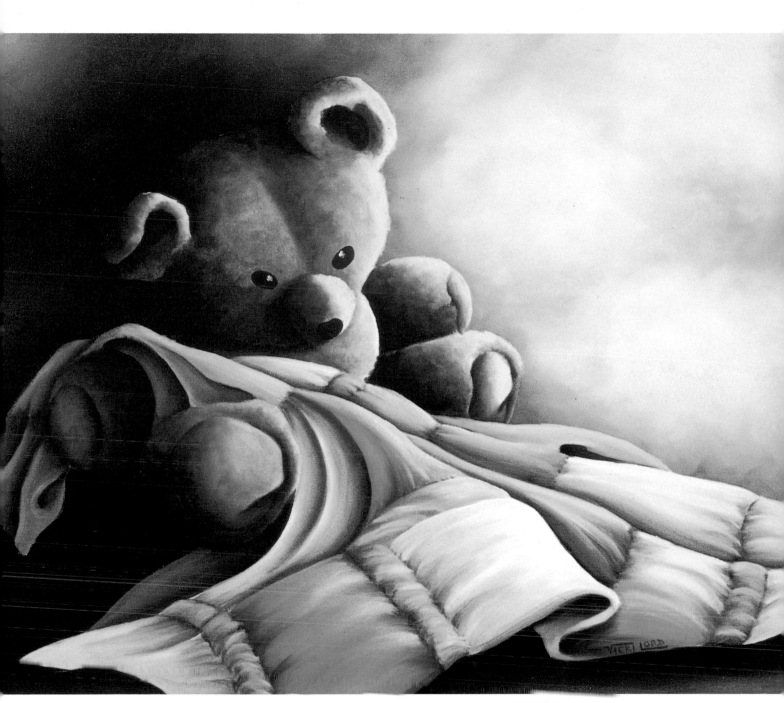

4. Highlights and Glazing

In this final step, create a little more drama and contrast. Using the darkest shadow color (in this case, cold dark and black) with enough water to make a transparent glaze, deepen the shadow areas. Place the glaze in the area that you want to appear the darkest, then wipe off your brush and add a little more water to fade the color.

Make the highlights with a mixture of white and a very small touch of Cadmium Yellow Light. Add them, without any water, to the spots that need to be brightest. Those on the quilt should be brushed on in the direction the fabric lies. Don't use too many highlights or they will loose their punch. Several layers of cold dark glazes were added to the shadow areas for contrast.

TEDDY AND QUILT
16″ × 20″, acrylic on canvas
Vicki Lord

DEMONSTRATION
Bold, Thick Pigment

Joseph Orr says, "Many times my acrylic paintings are mistaken for oils, an effect I deliberately try to achieve by working the pigment in a thicker manner. I like the pure richness of the paint straight out of the tube, so I do not use the gel mediums and other additives available.

"Acrylic's versatility is one of its greatest attributes. The artist can take it from thin to heavy application. Sometimes a single, thick load of paint applied in one stroke will say more than several washed, thin layers.

"Acrylic dries fast. In the event of a mistake or change of idea, the quick drying time allows you to recover and continue while the spontaneity of the moment is at hand. A lot of my images, or their beginnings, are produced on location. Acrylic is the ideal medium for painting alfresco, because of the immediate drying time.

"I favor untempered Masonite as a painting surface for my smaller paintings, but for large works I like using canvas."

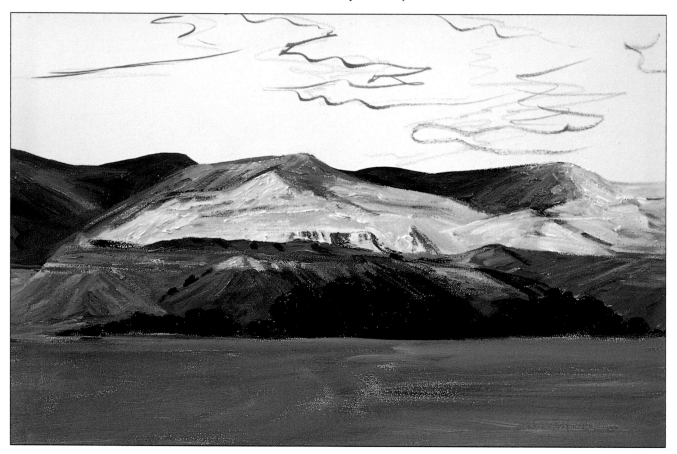

1. Establish General Patterns
Do a rough sketch of the idea you want to paint, being careful not to draw too much detail. Drawing in just the general pattern will allow you to be more spontaneous during the painting process. Loading the brush with lots of pigment, block in large areas, establishing light against dark and the mood of the painting.

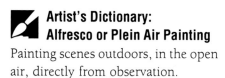
**Artist's Dictionary:
Alfresco or Plein Air Painting**
Painting scenes outdoors, in the open air, directly from observation.

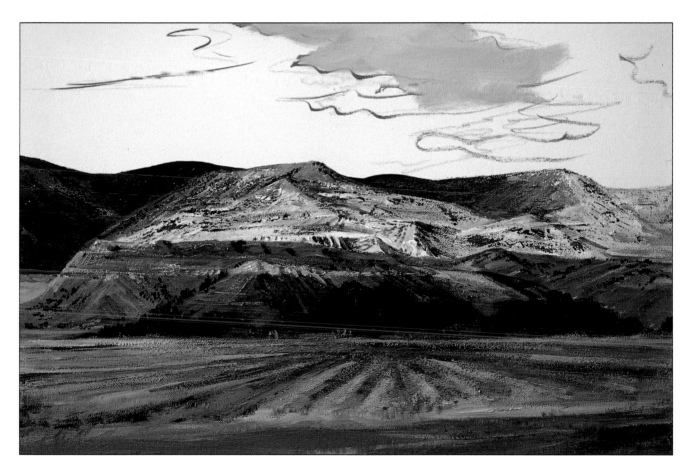

2. Earth and Sky
After painting in the middle and fore-
ground, start applying the sky area,
using sweeping motions with a large
brush. Be careful to work in the colors
that will complement the mountain.

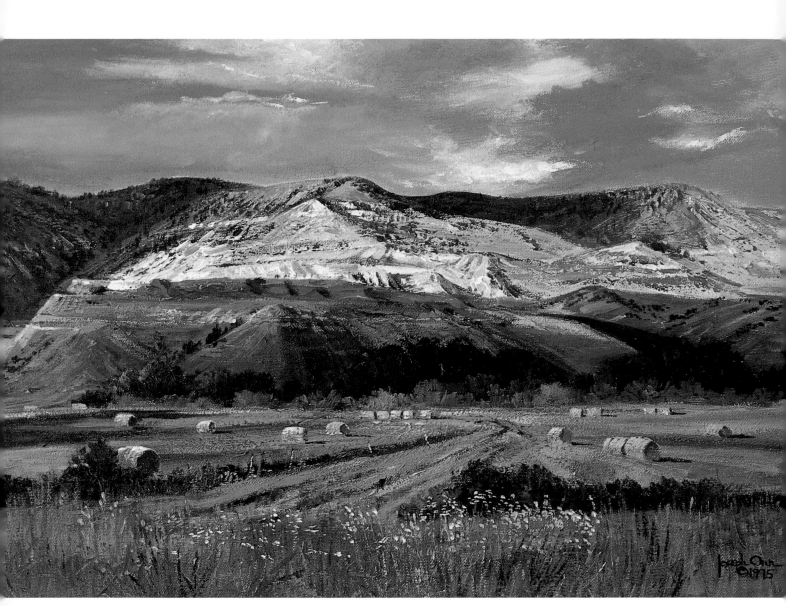

3. A Balanced Composition

Playing hard edges against soft ones helps to create a three-dimensional look in the painting. Use a 1-inch brush to paint the cloud formations, giving them a drifting effect. In contrast to the soft edges of the cloud formations, apply the mountain's sharp edges with a palette knife, giving it the textural effect of rocks and crags.

The completed painting shows a balanced pattern of values, color and objects that strengthens the composition.

To avoid having too much negative space in the foreground, add the hay bales. Their placement works to pull the viewer's eye through the composition.

HAYING SEASON
18″×24″, acrylic on canvas
Joseph Orr

Putting It All Together

The artist's objective in this scene was to bring out the mountain. Brightest colors were used on it, with cooler colors and more detail in the foreground grass and weeds to convey depth.

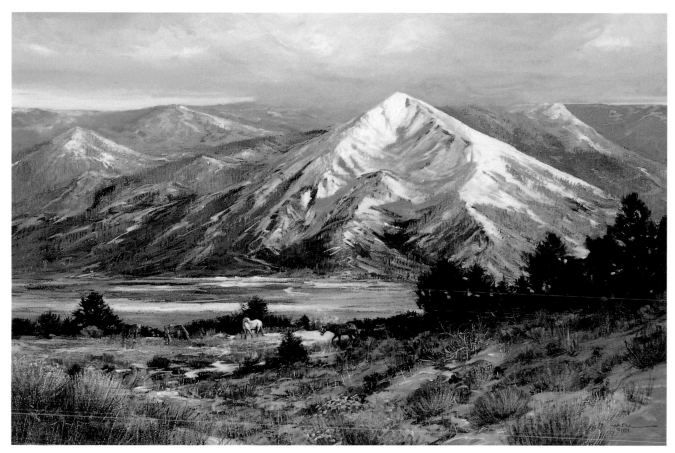

MOUNTAIN LIGHT
34″ × 48″, acrylic
Joseph Orr

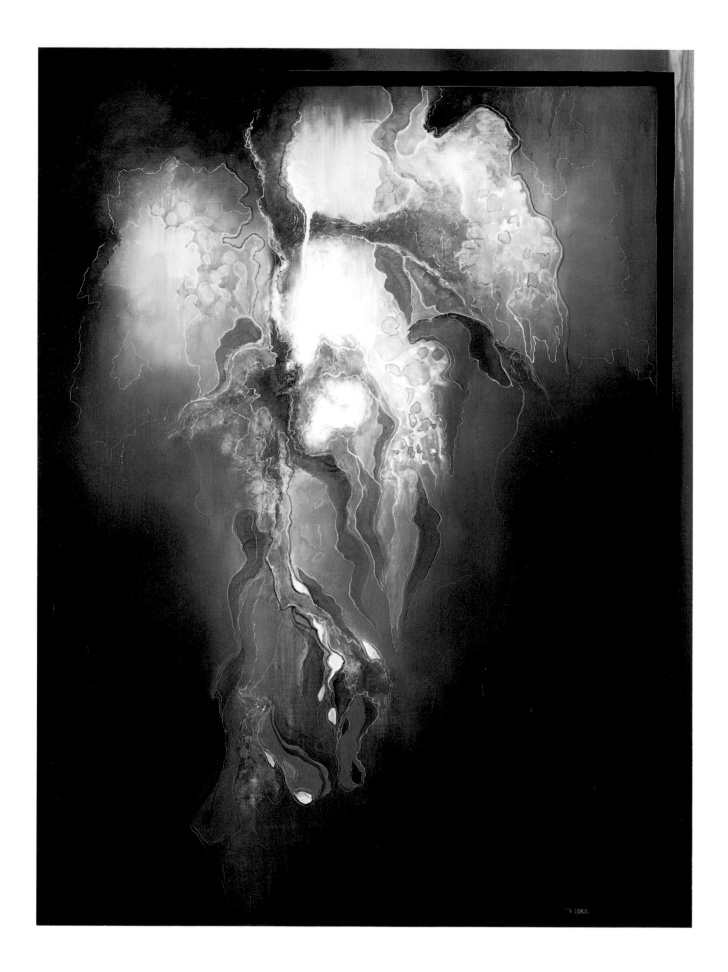

Chapter Five

EXPERIMENTING

The easiest way to become familiar with acrylics is through experimentation—exploring new techniques and materials. Beginning with no design in mind can lead to a truly fun experience. What could be easier? No decisions! No planning! Don't record what you see with preconceived notions, but add spontaneous interest. Try not to concentrate on producing a finished work of art.

Unusual materials, colors and texture add interest. Get started by picking out several hues at random, or perhaps ones that you would not normally use. Try colors that match your mood. Then let the paint tell you what to do. Pour it, brush it, even squirt it or spray it from bottles. Let paint run by tilting the surface. Beautiful independent shapes emerge when colors overlap and fuse. Let go and be spontaneous. Play! Explore new paths. Experimenting is a great way to grow as an artist! The possibilities are endless.

◄

METAMORPHOSIS OF LIGHT
30″ × 40″, acrylic and mixed media
on canvas
Vicki Lord

Color and Mood

Honey Creek started without Jon Krieger knowing exactly what he wanted as the outcome, but he knew that he wanted a loose feeling and overall light value in the finished piece. The direction of light played an important part here, as it does in all of his paintings. He started by washing broad areas of color over the entire surface. Then he began painting one area at a time, working with specific colors. Heavy brush applications evolved towards golds and yellows, filling the painting with light. Complementary purple was then added. This experiment in color produced a successful painting.

Krieger says, "My paintings are acrylic on museum board, watercolor paper or canvas. They are laid in from light to dark in much the same manner as traditional watercolors, but I finish the work in a heavy brush application to add energy and texture to the surface.

"I view my abstract paintings as emotional expressions, and I have come to find my color palette reflects how I am feeling at the time. The application of the paint, the contrast and the manipulation through scraping with the brush handle or addition of small prismacolor lines reflect how things are presently going in my life."

Experiment

Start pouring paint and water on a canvas or paper, then search for a compositional focus: colors that have mixed in an interesting manner, shapes that start to emerge, areas of high contrast, or subjects that are suggested by any of these combinations.

HONEY CREEK
30" × 38", acrylic
John Krieger

Using New Tools

Kathie George says . . . "the first step was drawing the design on 140-lb. cold-pressed paper with a marking pen . . . I then flipped the paper over so the design showed through on the back when placed on a light box and transferred the design from the front to the back with latex paint in a squeeze bottle. Black latex was used on the belts and identifiable items; salmon was used on the rest . . . I left the painting on the light box and as I continued to paint, the color appeared much lighter when applied. Thus, I automatically applied more color, though at this point I did not realize this.

"I used a mixture of Alizarin Crimson and Phthalo Violet for the reds, adding some Phthalo Blue occasionally. For navy blue I mixed Phthalo Blue, Phthalo Green and a touch of black; and for teal I mixed Phthalo Blue and Phthalo Green. I began by wetting the paper with a large flat brush, stroking soft colors (teal and red) onto the background. This floated onto the belts in some places. When this was dry, I began to define the background with darker values of the same colors, using a smaller brush. I didn't fill in the entire background, creating more interest. Then I removed the painting from the light box.

"The background color was rich and deep, so the belts didn't need a lot of work. I simply stroked some fluorescent gouache onto the belts. While some were wet, others were dry when detail was added."

INTERTWINED
22″ × 30″, mixed media on
watercolor paper
Kathie George

Artist's Dictionary: Light Box

A translucent glass- or plastic-topped box with a light inside. Often used for tracing.

Creating Texture

Artist's Dictionary: Flyspecking or Spatters

Irregularly spattered flecks of paint often used to depict textures from nature, such as pebbles on a beach or falling snow. The paint should be of a soupy consistency. Holding the brush at an angle to the painting surface, pull your finger across the brush tip towards you, causing the paint to fly off in little specks.

Glaze

A transparent layer of paint.

Overglazing

A glaze applied on top of another layer of paint.

Scratching Out

Technique by which a palette knife or other object is drawn across a painted surface.

Experiment

Try dropping alcohol into paint of varying degrees of wetness. The amount of water mixed with the paint produces different effects and irregular shapes. Application of the alcohol in different ways, such as spattering or dropping it from an eye dropper, also causes the result to vary.

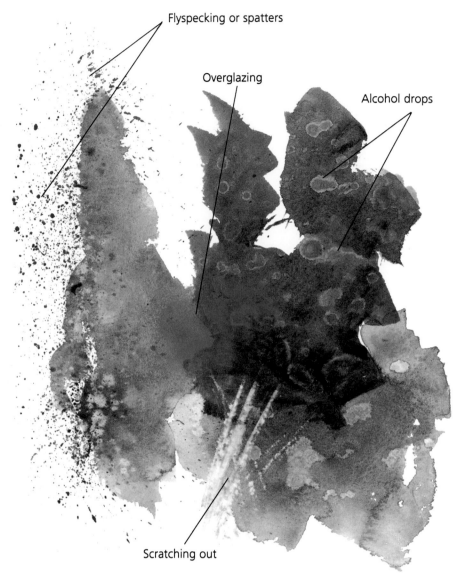

Flyspecking or spatters

Overglazing

Alcohol drops

Scratching out

Artist's Dictionary: Clear Wet Media Acetate

Transparent sheet plastic specially treated to accept all liquid media.

Gouache

Permanent opaque watercolor.

Nonrepresentation

A style of art that does not seek to represent objects as they appear in nature.

Opaque

Opposite of transparent; not allowing light to pass through.

Wash

A thin application of paint.

You Can't Make a Mistake

"I describe acrylic paints as user-friendly," says Louise Cadillac. "I further instruct my classes that they can't make a mistake, nor ruin a sheet of paper. One of the most outstanding characteristics of acrylic paint is its quick drying time. Overpainting can be done almost immediately. As soon as you realize that you wanted something to be more transparent, or it's the wrong color, or you'd like more of a shape . . . Presto! You can change it. Fast drying allows you to enlarge, correct, discard or reclaim any or all of the painting in progress. The beginner finds a freedom, an abandonment akin to that of school children who paint the most delightful, insightful, creative pieces of art.

"Acrylic's quick drying time also permits the use of many techniques at once as well as the discovery of new ones. In my painting *Monolith II*, for instance, you can readily pick out many techniques, from alcohol drops to glazing. Note particularly the towel stamping, lines drawn with alcohol, and scratching through to reveal underlayers."

Hint

When you'd like to "try on" an idea, but remove it if it doesn't work, try the following. Paint over your acrylic with gouache, which can be wiped off. Or, place clear wet media acetate over the painting after paints have dried. This produces a clear shield or window on which you can try out ideas, instead of adding directly to the painting.

MONOLITH II
40" × 30", acrylic and mixed watermedia
Louise Cadillac
Collection of Synergen, Inc.

Painting Adventure

Marilyn Hughey Phillis says, "This work was a great adventure in painting. I worked on Crescent cold-pressed watercolor board, no. 114. All four edges were rubbed with paraffin wax to prevent water from seeping underneath. I roughed in a tentative design with warm tones of watercolor and made sure that plenty of white remained. I had been working on a series of paintings relating to earth energies, and the conceptual impetus for this work began with that feeling. Color emphasis would be warm, but would have cool contrasts and strong values for drama.

"Working with Golden fluid acrylics gave me freedom to apply thin, multiple strokes of paint. There is both containment and flowing energy within the painting. A small amount of watercolor crayon was used for some underlying textural effects, but is obscured by the overlaying of many acrylic glazes. When some of the acrylic was just damp, alcohol was sprayed on to cause an interesting textural separation of paint surface. Tissue pickup created another textural effect, as did various forms of spattering. The fine line work was done with a fine round brush, such as a rigger. The cool blue tones added a necessary color balance as did the dark areas."

GRAND FINALE
30" × 40", acrylic, watercolor and watercolor crayon
Marilyn Hughey Phillis
Private collection

Artist's Dictionary: Tissue Pickup
Lifting wet paint from the surface of a piece using a tissue.

Water-Soluble (and Watercolor) Crayons and Pencils
These are crayons and pencils that can be used wet or dry. A wash effect is created when brushed with water after application. May also be dipped in water to create texture.

Imprints

Various objects can be used to leave an imprint on a painting surface, adding many textural effects:

1. The objects are placed on a wet painting surface.
2. More paint is added on top of the objects, in varying consistencies, to achieve the desired value and sharpness of the outlines.
3. Once the surface is dry, the objects are removed.

This can be used as a design in itself or as a background for a more detailed process.

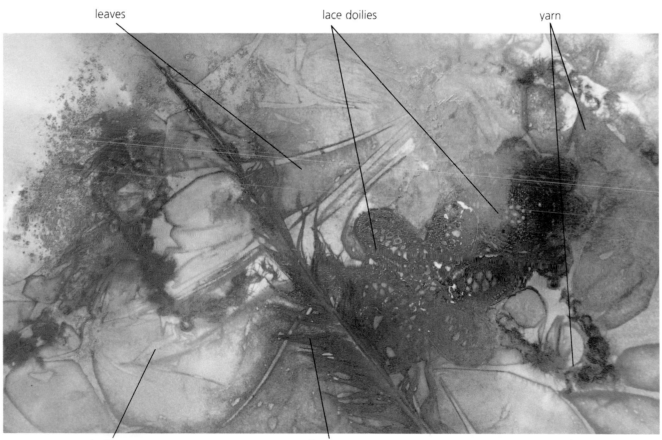

leaves

lace doilies

yarn

plastic wrap

feather

Texturing With Sand and Symbols

Mary Todd Beam says, "We had just returned from a trip to the West, and the wonderful colors and textures were still burning in my mind. I was anxious to experiment and find a way to capture these textures and visual stimuli. I mixed sand with gesso and coated certain areas of the painting with this mixture. After this dried, I could paint on it or just leave the nat-ural color of the sand. I like the symbols that are used by the Indians and wanted to incorporate some of them. In this type of experimental work, I let the design develop along the way, responding to my natural instincts wherever possible. I enjoy the texture of the carpenter's pencil to make graphite lines into the gesso and sand mixture. This must be done on a dry surface.

"Sometimes in the design I like to make a space division in unusual places. My hope is that the viewer will read this division like the pages of a book that is unfolding before them. If during this process I have piqued their interest and curiosity, my goal is achieved."

WESTERN TIME
20" × 22", acrylic mixed media on illustration board
Mary Todd Beam

Experiment

Work creatively from photographs and pictures, even those that are some-what abstract or out of focus. Turn them upside down and sideways. Squint. Crop. Look for shapes, contrast and interesting designs. Don't copy the pictures, just use them, or pieces of them, for inspiration or to generate new experiments with abstract ideas. Add your own colors, techniques and ideas.

 Artist's Dictionary: Modeling Paste or Gel Medium

Thick acrylic paste, which is easily modeled while wet, and is used for building up an area with texture.

Relief

Raised effect in which forms are distinguished from a surrounding plane surface.

Collage

"Acrylics lend themselves beautifully to collage techniques," says Louise Cadillac. "One reason is that acrylic medium is an excellent glue. Just brush the medium on the painted surface, apply collage paper over it and continue working, painting over the collage paper if you wish. The resultant imagery can be dramatic and exciting. In *Pink Square* I combined collaged metallic paper with painterly techniques and geometric forms, producing optical reversals." The small pink square is painted, while the large one is collaged.

Experiment

Get out your old, cast-off paintings and disasters (we all have them)! Try experimenting with textures, such as rice paper collage, on top of the old designs.

PINK SQUARE
30″ × 22″, acrylic and watermedia
with metallic collage
Louise Cadillac

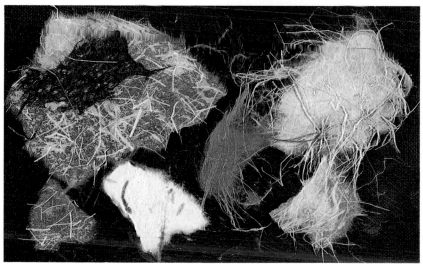

113

Adding New Materials

This painting evolved from wanting to explore textures. I started with a 4′ × 6′ canvas and masked off areas where I wanted to keep a smooth surface. I then used a heavy gel medium to create a random texture on the background. I applied more gel where I wanted the circles and used a hair comb for texture. I painted metallic gold acrylic onto this. Where I wanted a brighter metallic, I mixed a powdered metallic watercolor with acrylic gloss medium. While this was drying, I applied other colors and spattered paint for even more texture. I used a dark umber mixture to antique the heavily textured area, applying a thin wash and then wiping off the high spots. Gold and silver leaf were added for accents, and if you look closely, you can see small geometric forms applied with acrylic and hand stamps adding small accents or partially hidden visual messages.

▶

THE EMPEROR'S WISH—AN AMALGAMATION OF TEXTURE
4′ × 6′, mixed media on canvas
Vicki Lord

▼ Detail

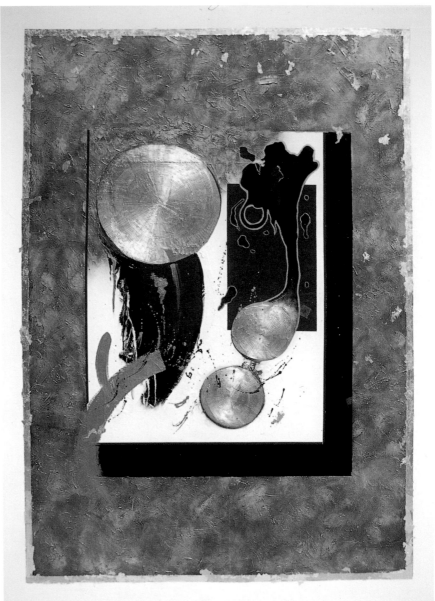

Artist's Dictionary: Antiquing

Glazing with a dark color to create an appearance of age.

Gilded

Covered with gold.

Gold and Silver Leaf

Very thin sheet metal.

Powdered Watercolor

Opaque watercolors available in powder form, to which water or medium may be added as the binder.

Experiment

Try various combinations of textures and techniques in one painting. Find creative new uses for the same old products. I got carried away in this painting: modeling gel, metallic paint, resists, gold and silver leaf, powdered watercolor and regular acrylics.

Realism and Nonrepresentation

"*The Yellow Rose of Texas* and *Framework* both have dominant nature-based curvilinear shapes and geometric abstract backgrounds. Both arrangements have a light shape positioned in front of a dark background. The figure and the skull required a minimal amount of drawing. The negative spaces were developed on an intuitive level."

Al Brouillette says, "My use of acrylics followed the same general process in both works. Transparent washes of pure color were brushed onto my painting surface in a casual manner. Occasionally I used an alcohol or water spray to add some texture. Water-soluble crayon and colored pencils were also introduced into the painting for their linear additions. Each layer was thoroughly dried before the next was applied. Once dry, acrylics cannot be lifted . . . which is an advantage. When I felt satisfied with what I had as an underpainting, I gradually intensified and darkened my transparent values, slowly moving toward my darkest darks. The continuity of these movements was interspersed with the addition of colors mixed with small amounts of white for my middle range of light values. I began to use larger amounts of white, moving toward my very lightest colors. Developing a wide range of values produced the overall, and final, designs. Delicate glazes of transparent color, both warm and cool, were then brushed into each painting to enhance colors."

Artist's Dictionary: Pure Color

Pigment straight from the tube.

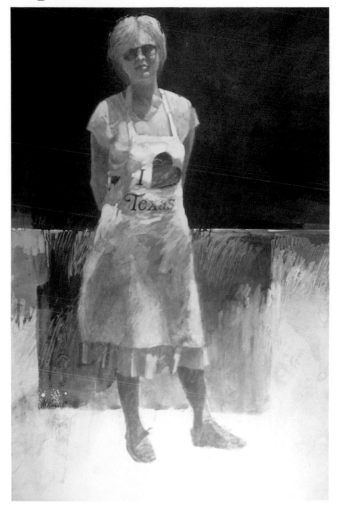

THE YELLOW
ROSE OF TEXAS
30″ × 22″, acrylic
Al Brouillette

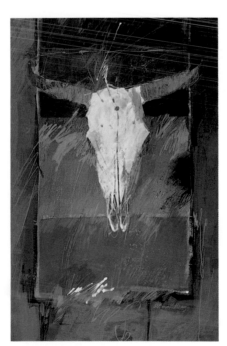

FRAMEWORK
28½″ × 18½″, acrylic
Al Brouillette

Exploring Alternative Surfaces

A variety of painting techniques can be used on different surfaces, so you are limited only by your imagination.

OFFERINGS
24″ × 28″, acrylic on birch plywood
Fran Larsen

Fran Larsen says, "The folding screen, Offerings (left), and the double-sided, freestanding sculpture, East Meets West (below), are painted with layers of modeling paste, gels, and iridescent, metallic and matte acrylic. They are paintings of which you can see both sides. They grew out of the Hispanic New Mexican folk art tradition."

EAST MEETS WEST
15″ × 20″, acrylic polychrome on birch plywood
Fran Larsen

Floorcloth

MY GEORGIAIOUS SUN
6′ × 6′, acrylic on canvas
Daryl Weil

This floorcloth painted by Daryl Weil can be used as an area rug or a wall hanging. Primed canvas is sold with pre-formed edges for floorcloths if you don't want to hem the edges and prepare the surface before painting.

Frames

The frame surrounding a painting is a very important part of its overall visual effect. Some artists choose to incorporate the frame into the design of the painting.

"Siesta Time is a watermedia painting involving a frame painted in matte, iridescent and metallic acrylics . . . " says Fran Larsen. "The painting itself is watercolor on board with metallic acrylic passages."

SIESTA TIME
24" × 28", acrylic and watermedia
with acrylic painted frame
Fran Larsen

OUR CAT
24" × 22", acrylic with hand-painted
frame, Jan Miller. Courtesy of Joyce
Petter Gallery, Douglas, MI.

BLUE STILL LIFE
38" × 48", acrylic with hand-painted
frame, Jan Miller. Courtesy of Joyce
Petter Gallery, Douglas, MI.

Jan Miller says, "I hand-paint each frame to suit the individual painting. This adds another dimension to my work by extending the painting. It has been a lot of fun to design these frames. They are made of wood, gessoed first and then painted with brushes and sponges to get various effects. When satisfied, I finish with a gloss varnish."

Found Furniture

Jan Miller thinks of her "found furniture" as her contribution to the world's recycling problem. She starts with a used piece of furniture and watches it evolve into a three-dimensional painting using acrylics. "I never know what the piece will be," she says. "I start with a color, and as I paint it is almost like automatic writing. An intuitive feeling guides me as an idea evolves. The shape of each individual piece determines and brings forth the imagery."

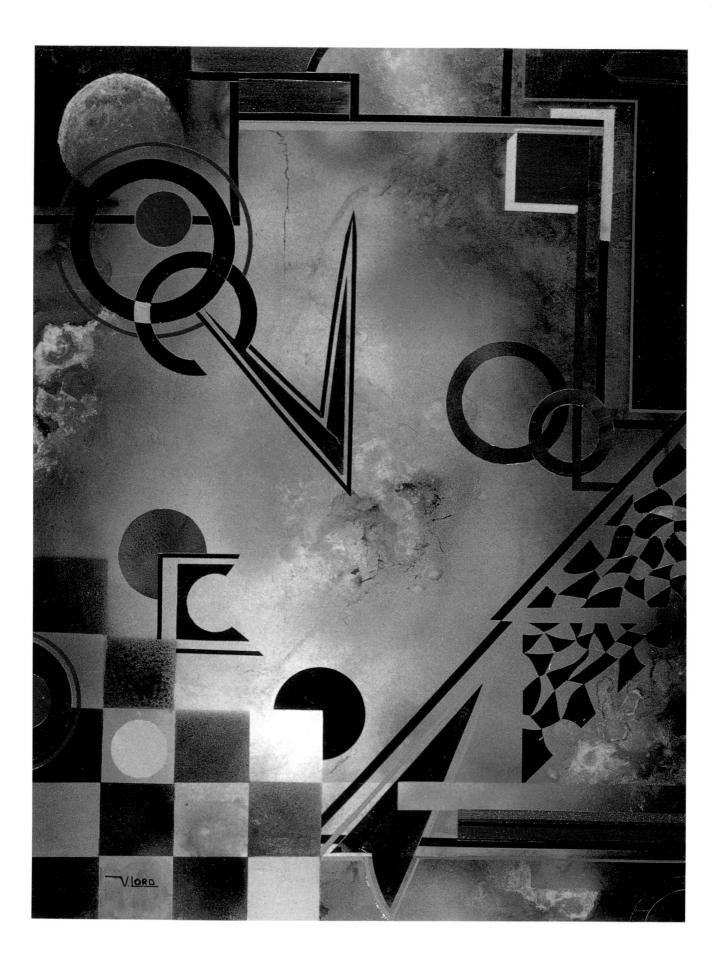

Conclusion

As you have seen, there are many ways of using acrylics. They provide a source of continual experimentation, a never-ending journey. I hope this book has helped you develop a better understanding of the painting process, and that you are inspired to experiment with these techniques and develop your own expressive style.

This book is merely a starting point on a challenging and exciting journey. It provides a mere taste of what lies ahead, what might be experienced. As artists, we all have times when we are uncertain how to progress. Sometimes, through inspiration and experimentation, we come across a new and exciting path. And sometimes we paint by some process that proceeds on a subconscious level, finally delivering us to that "moment" when we know what to do next. Sometimes it happens while painting, sometimes while listening to music, and sometimes at 3:30 A.M. And then a new journey begins. . . .

BLUE ICE
30″ × 22″, acrylic and watermedia on paper
Louise Cadillac
Collection of Nancy Marple

◄

DIFFUSION OF METALS
24″ × 30″, acrylic and mixed media on aluminum
Vicki Lord

Contributing Artists

Mary Todd Beam
400 N. Seventh St., Cambridge, OH 43725

Memberships: American Watercolor Society; National Watercolor Society; Ohio Watercolor Society; Society of Layerists in Multimedia

Honors and Awards: AWS; NWS; Ralph Fabri Medal; Lone Star Award; Who's Who in American Art

Workshops: Contact above address

Al Brouillette
1300 Sunset Ct., Arlington, TX 76013

Memberships: National Academy of Design; American Watercolor Society; National Watercolor Society; Rocky Mountain Watermedia Society

Honors and Awards: Gold and Bronze Medal—AWS

Workshops: Contact above address

Louise Cadillac
880 S. Dudley St., Lakewood, CO 80226

Honors and Awards: AWS Gold Medalist; AWS; Juror

Workshops: Contact above address

Kathie George
212 Brydon Rd., Kettering, OH 45419

Memberships: Ohio Watercolor Society; Florida Watercolor Society; Southern Artists League

Author: Three instructional painting books

Workshops: Contact above address

John Krieger
5509 Ridgemont Ct., Midland, MI 48640

Galleries: Vallerie Miller Fine Art, Palm Desert, CA; Perry Sherwood Fine Art, Petoskie, MI

(continued on p. 124)

◄

CHEROKEE MOON
30" × 40", acrylic on illustration board
Mary Todd Beam

►

GET UP AND CLOSE THE WINDOW
38" × 30", acrylic
John Krieger

Contributing Artists

(*continued from p. 122*)

Fran Larsen
2221 Callecita Membreno, Santa Fe, NM 87505

Honors and Awards: American Watercolor Society; National Watercolor Society; Watercolor USA; Rocky Mountain Watermedia Exhibitions

Workshops or Juror: Contact above address

Milton Lenoir
86 McMurrian Rd., Phenix City, AL 36869

Author: Six instructional acrylic books

Workshops: Contact above address

Jan Miller
40 Charlotte St., St. Augustine, FL 32084

Permanent Collections: Illinois State Fine Arts Museum, Springfield, IL; Museum of Fine Art, Ft. Lauderdale, FL; First National Bank of Chicago; Schiff, Hardin & Waite, Washington DC; Blount Collection, Schaumburg, IL; Borg-Warner Corp., Chicago, IL

Joseph Orr
R.R. 1, Box 1229, Osage Beach, MO 65065

Galleries: Quast Galleries, Taos, NM; Altermann & Morris Galleries, Houston, TX and Santa Fe, NM; Leopold Int. Gallery, Kansas City, MO

Marilyn Hughey Phillis
72 Stamm Circle, Wheeling, WV 26003

Memberships: American Watercolor Society; National Watercolor Society

Honors and Awards: Gold Medal, Watercolor Ohio; Moschetti Memorial Award, Rocky Mountain National Juried Exhibit

Workshops: Contact above address

Mark Polomchak
Court Gallery, Courthouse Square, Crown Pointe, IN 46307

Gallery and Workshops: Contact above address

Maureen Schultz
P.O. Box 704, 7 Dogwood Lane, Nellysford, VA 22958

Author: *Folk Art Americana*, *Kitchen Still Life* and instructional painting books

Workshops: Contact above address

Daryl Weil
7676 N. Shadow Mountain Rd., Paradise Valley, AZ 85253

Gallery: The Art of the Toy, Scottsdale, AZ

Michael Wheeler
P.O. Box 187, Manchester, KY 40962

Honors and Awards: US Art Magazine Merit Award; Arts for the Parks; Best of Show, Boston Mills Artfest

Solo Exhibitions: Headley Whitney Museum, Lexington, KY; Classic Fine Art Gallery, Carmel, CA

Galleries: Classic Fine Art Gallery, Carmel, CA; James Gallery, Pittsburgh, PA

▶

HEAD STUDY
13″ × 17″, acrylic on MiTeintes paper
Maureen Shultz

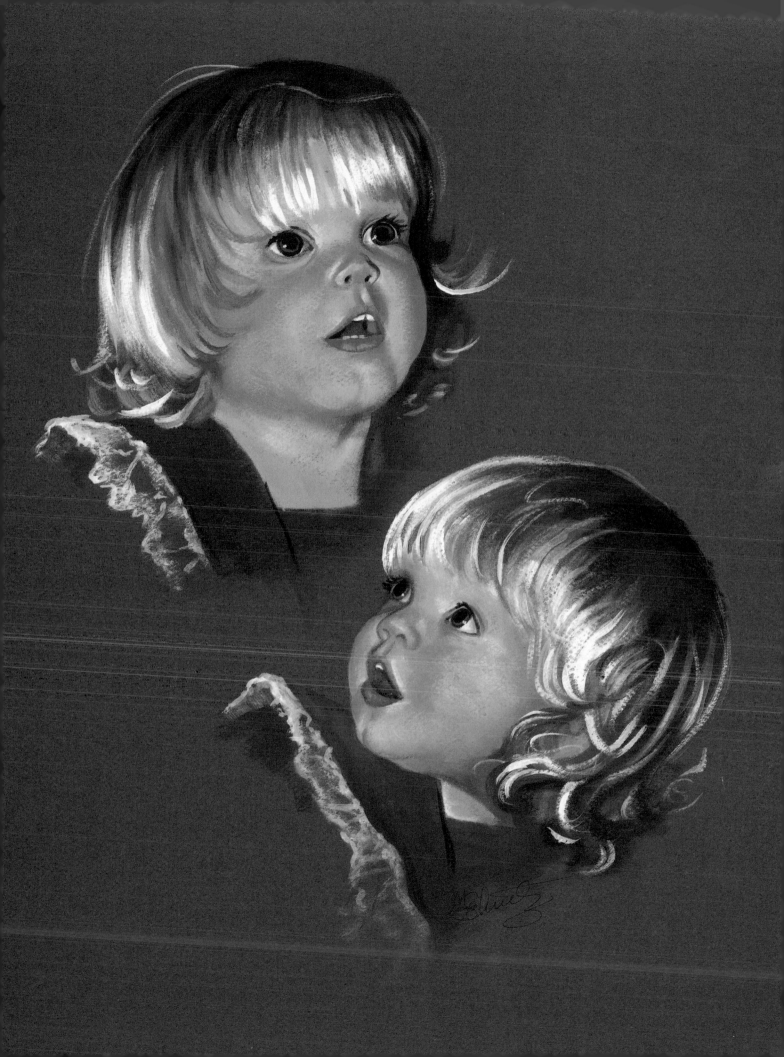

Index